SEAMUS MURPHY

THE REPUBLIC

SEAMUS MURPHY

ALLEN LANE
an imprint of
PENGUIN BOOKS

For Smita, of course

Every life is in many days, day after day.
We walk through ourselves, meeting robbers, ghosts, giants,
old men, young men, wives, widows, brothers-in-love
But always meeting ourselves.

James Joyce, *Ulysses*

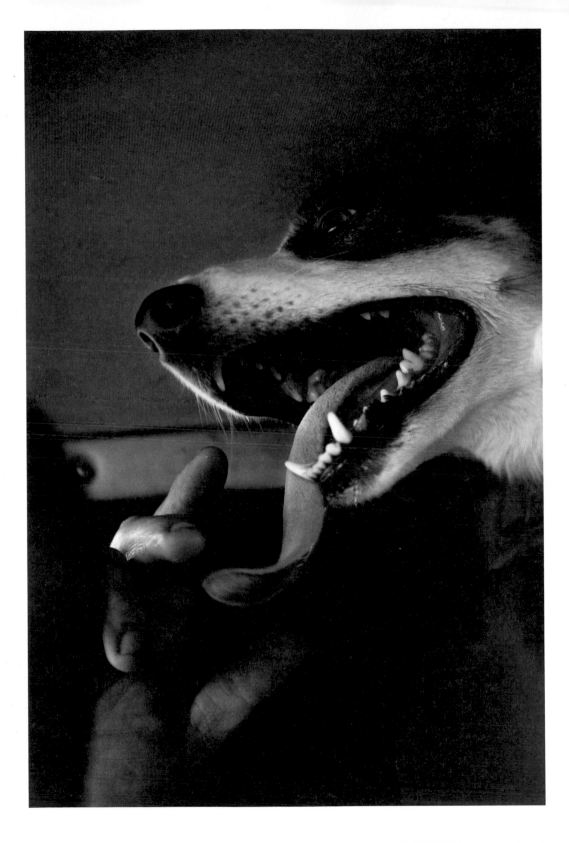

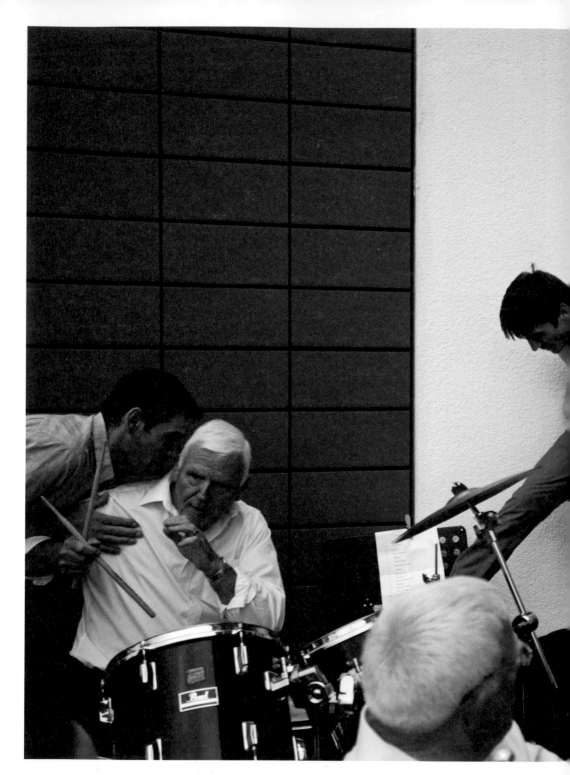

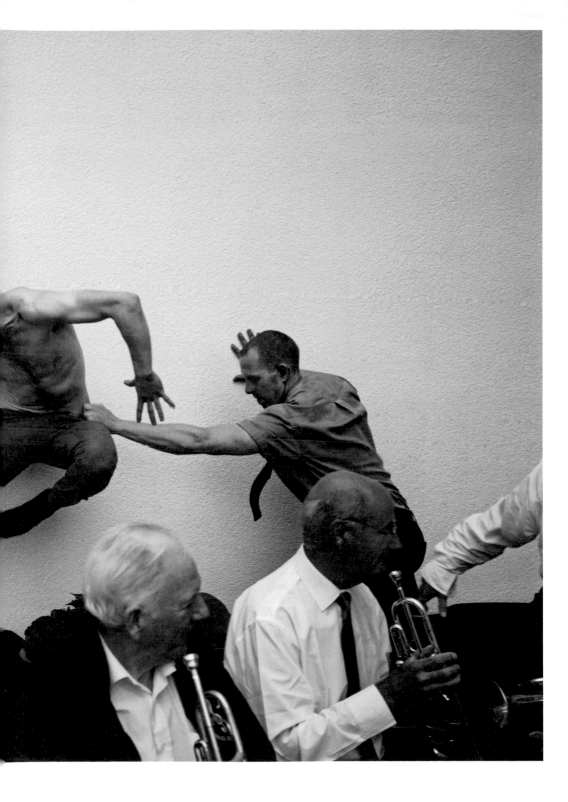

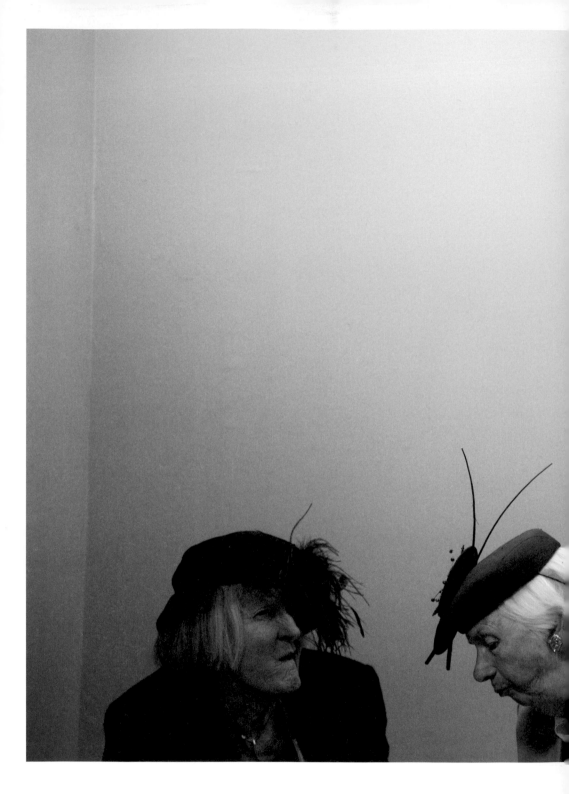

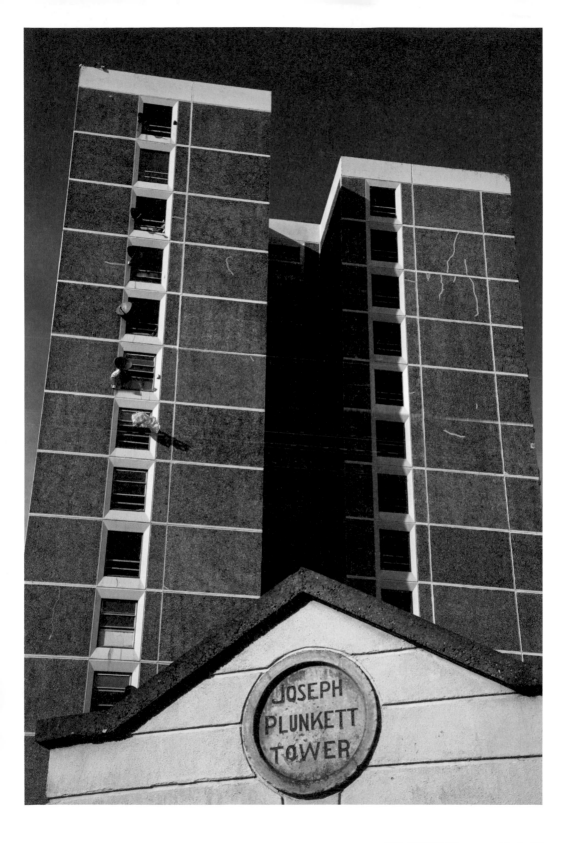

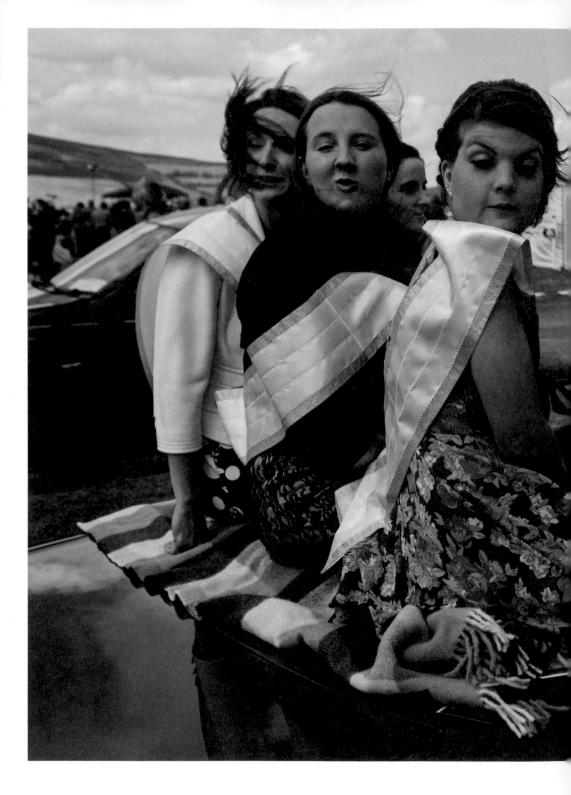

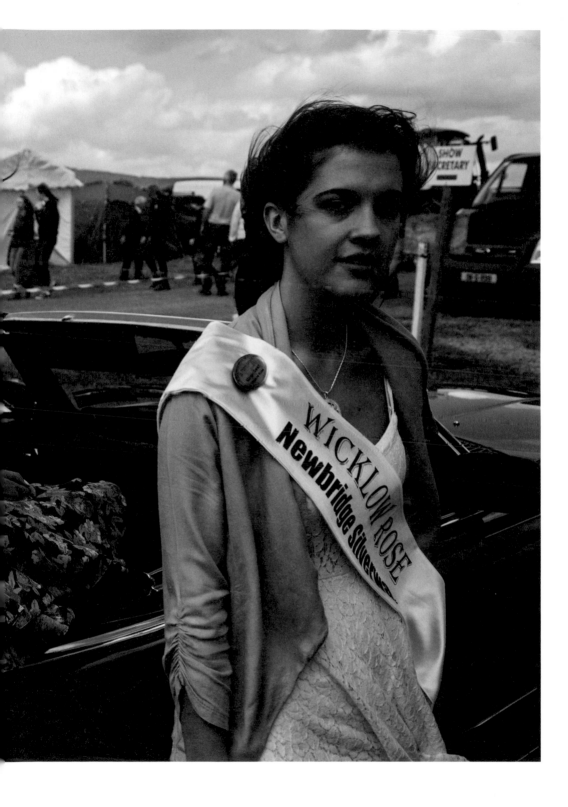

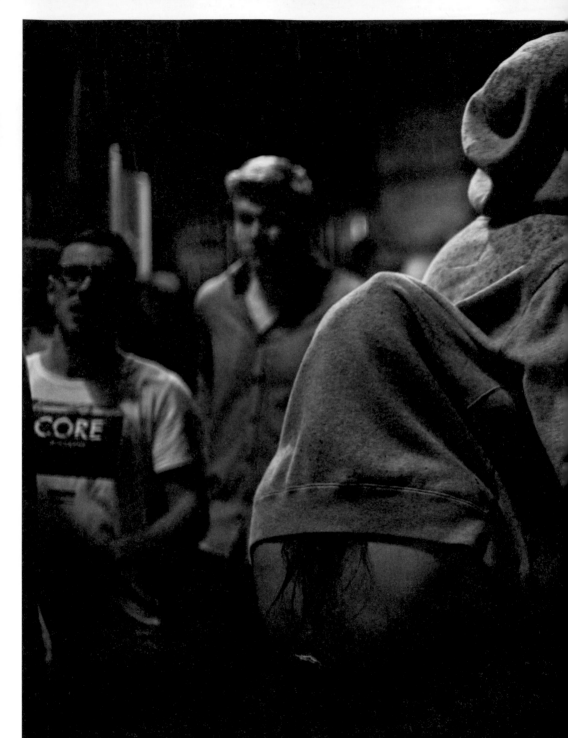

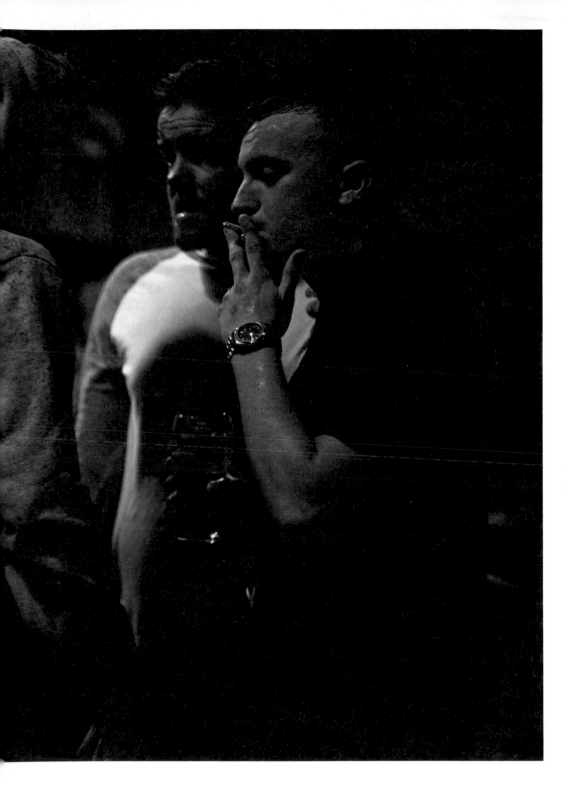

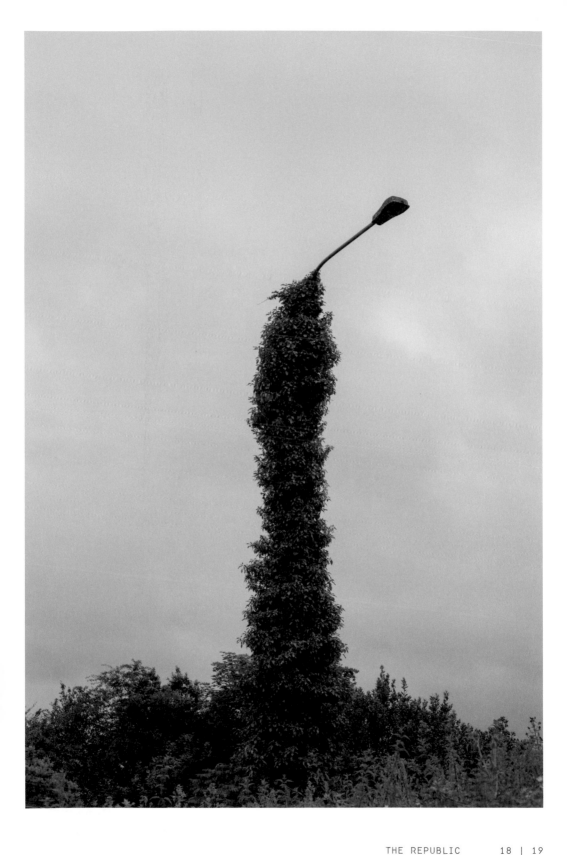

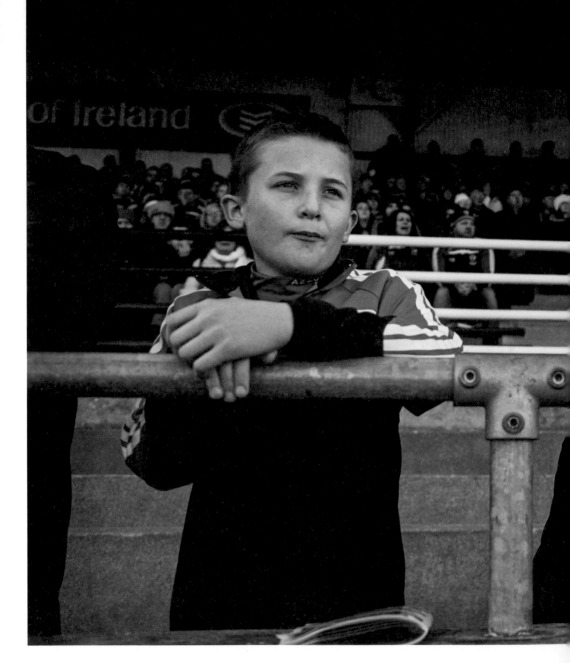

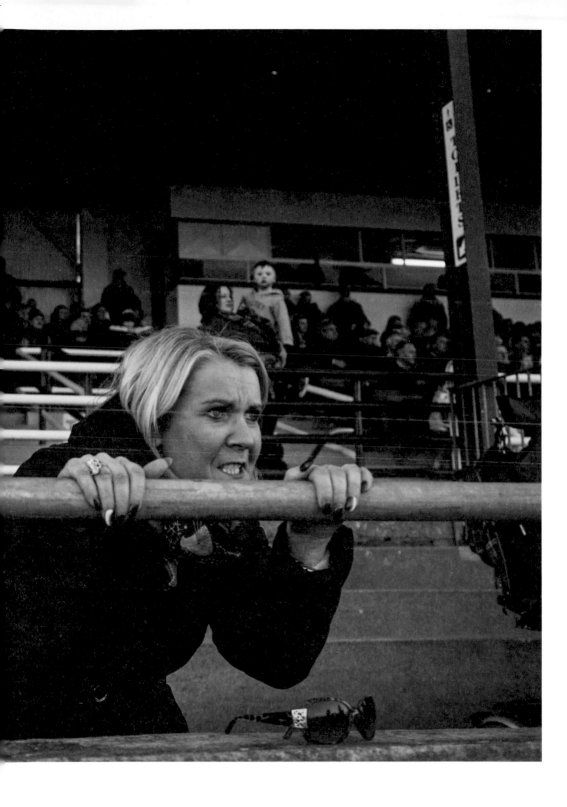

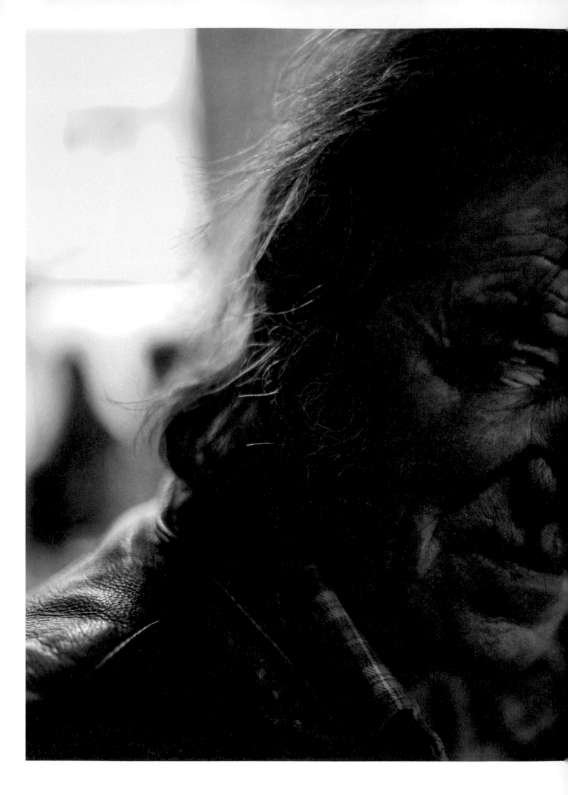

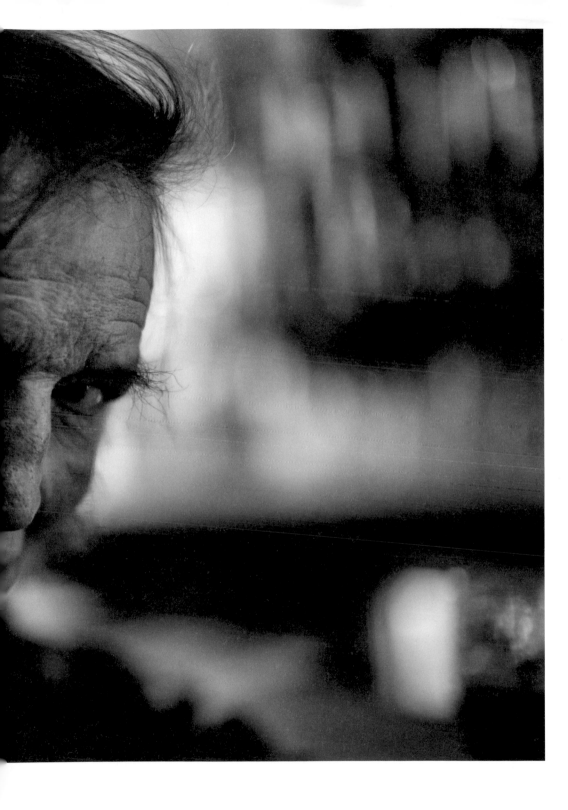

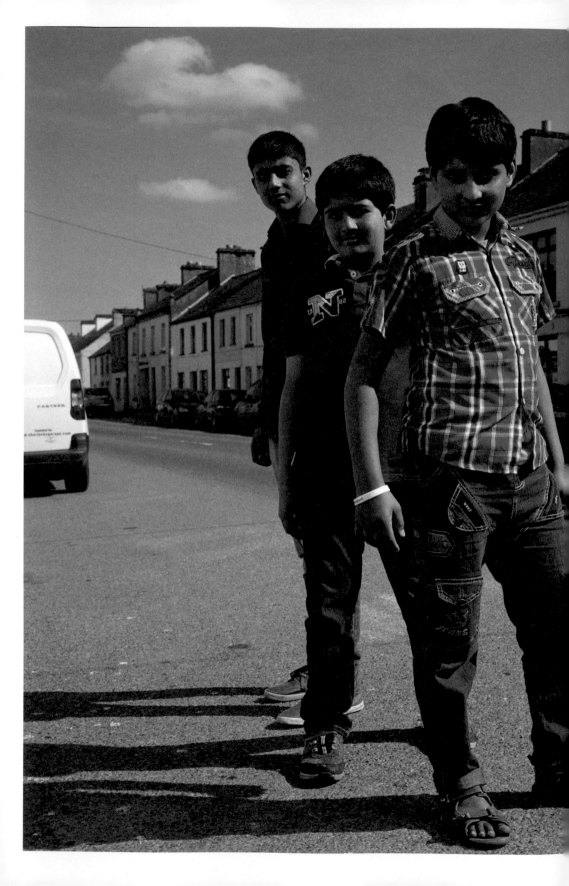

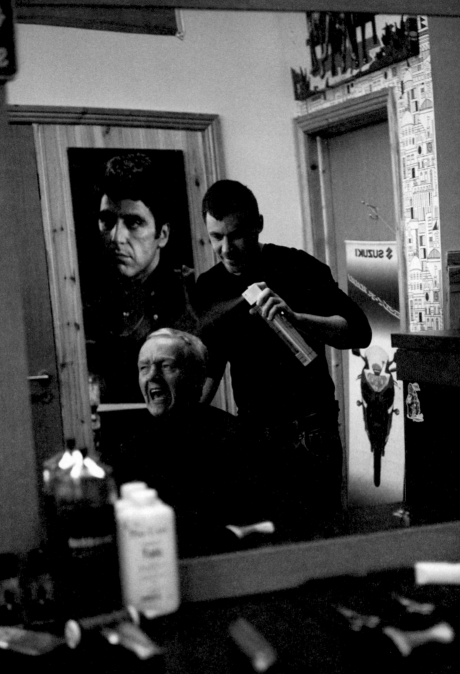

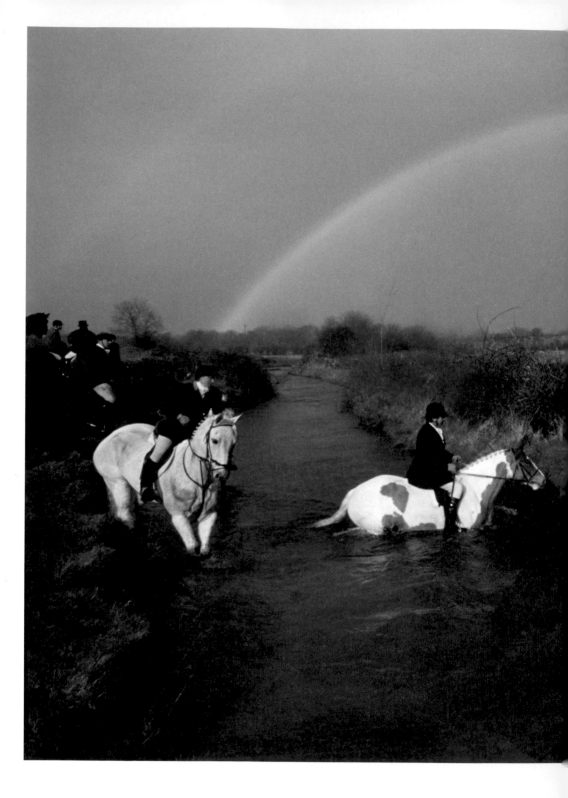

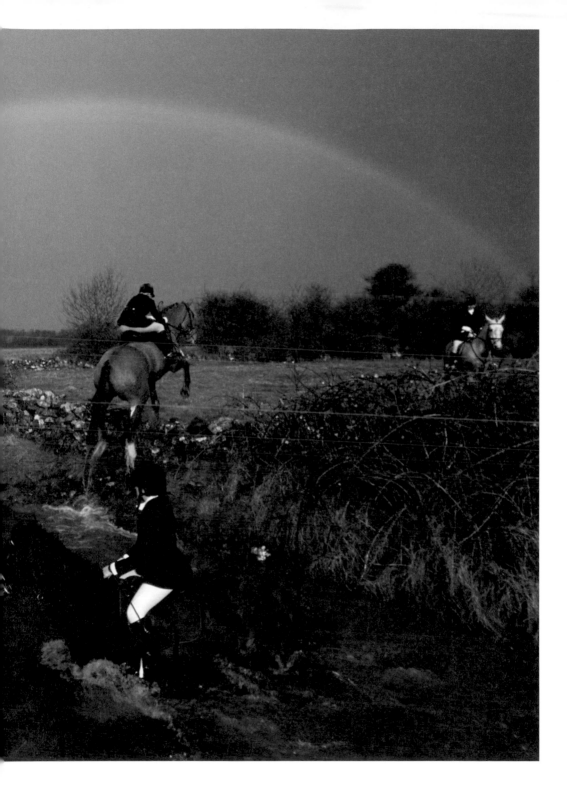

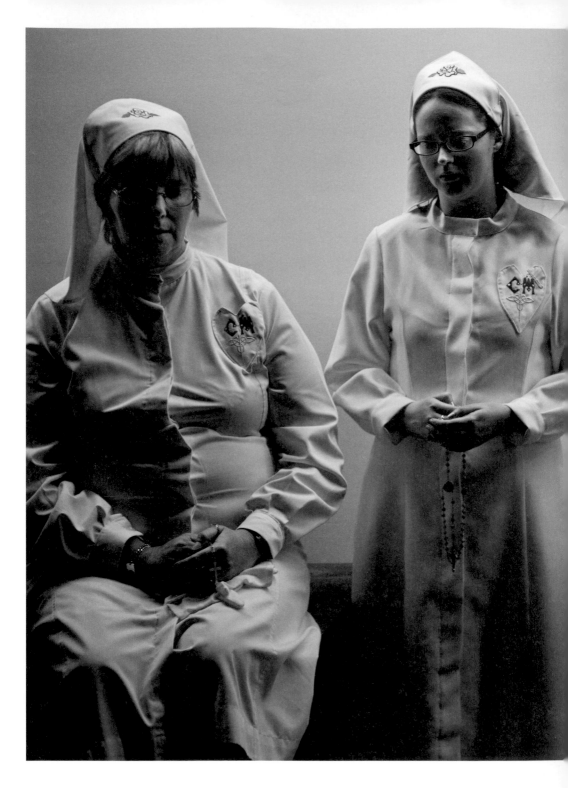

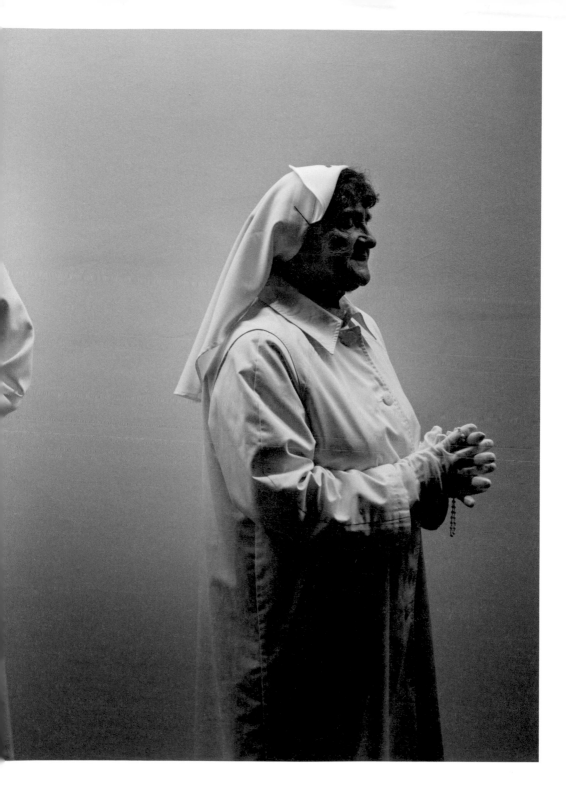

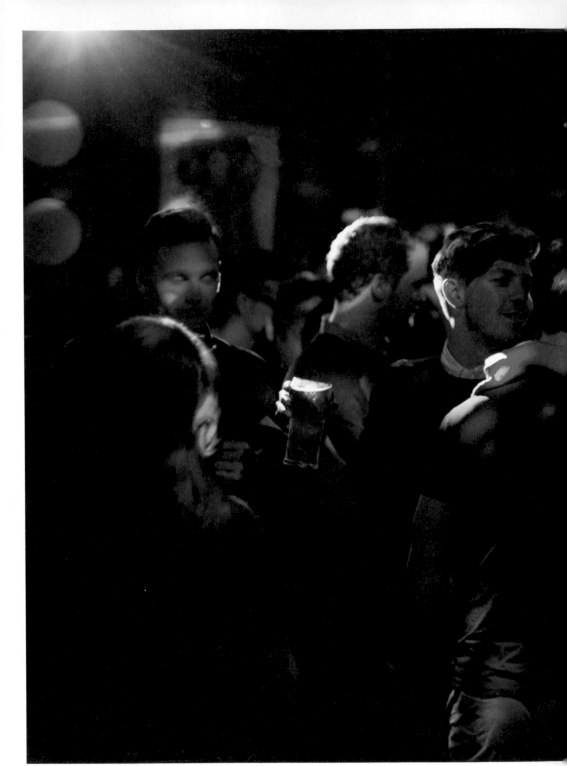

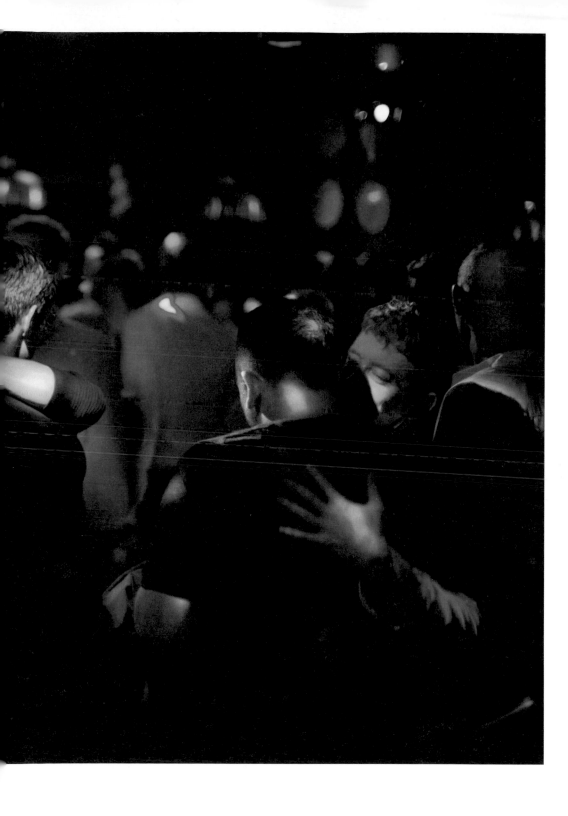

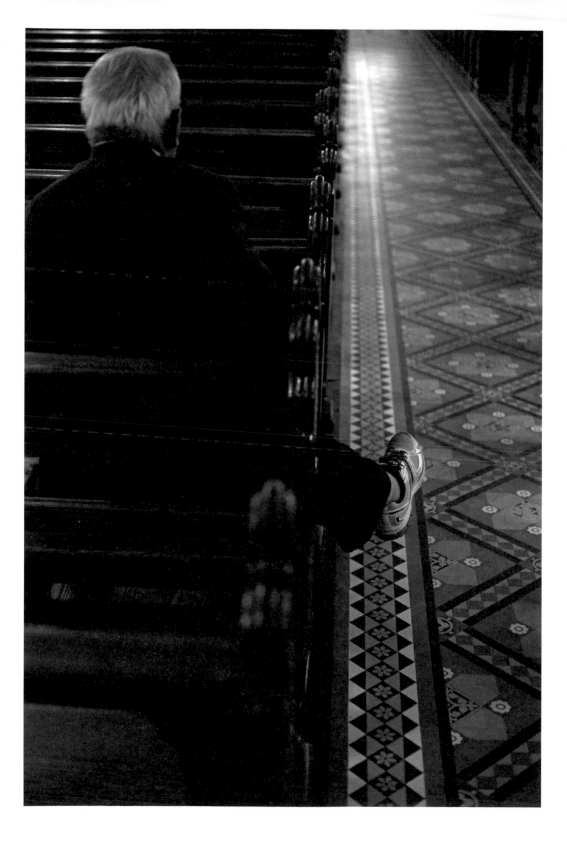

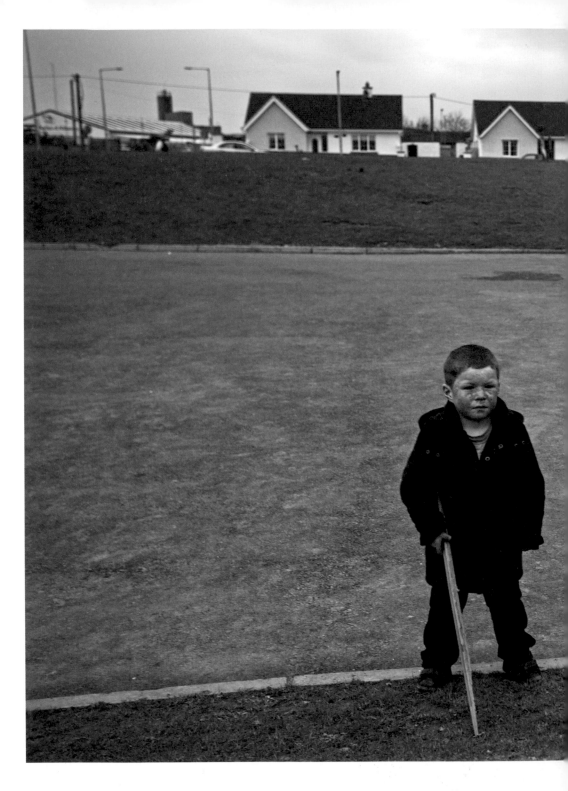

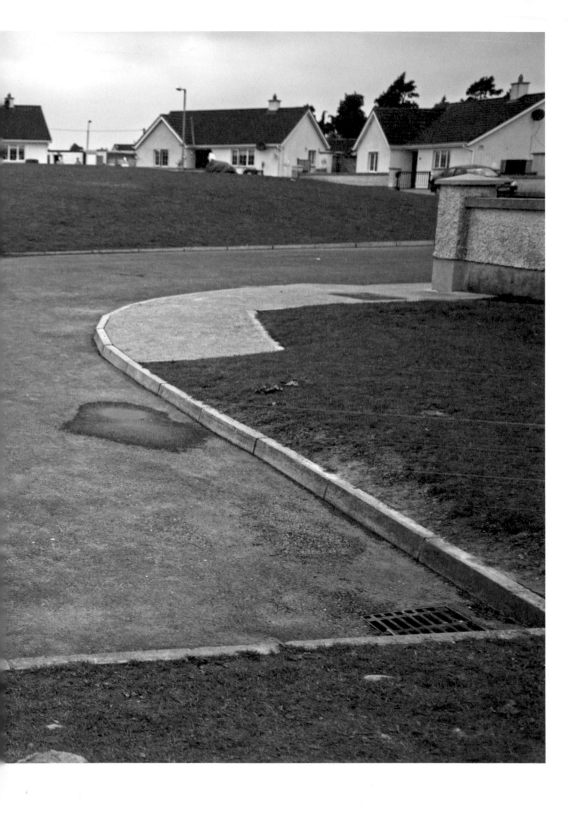

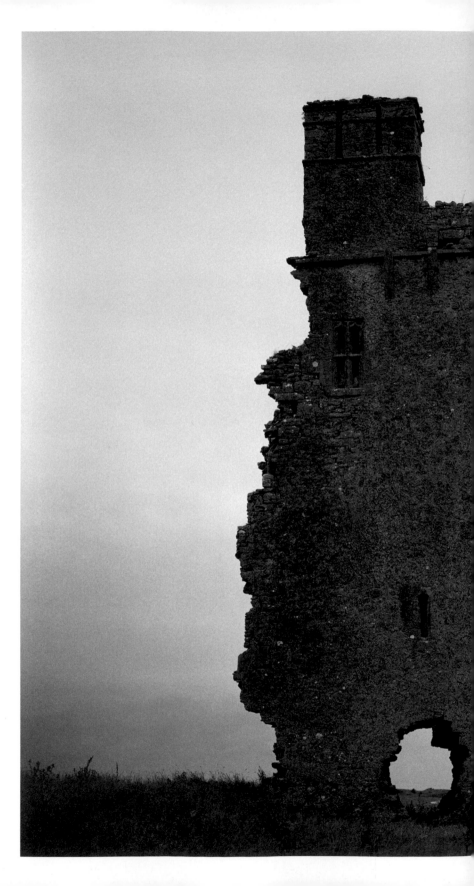

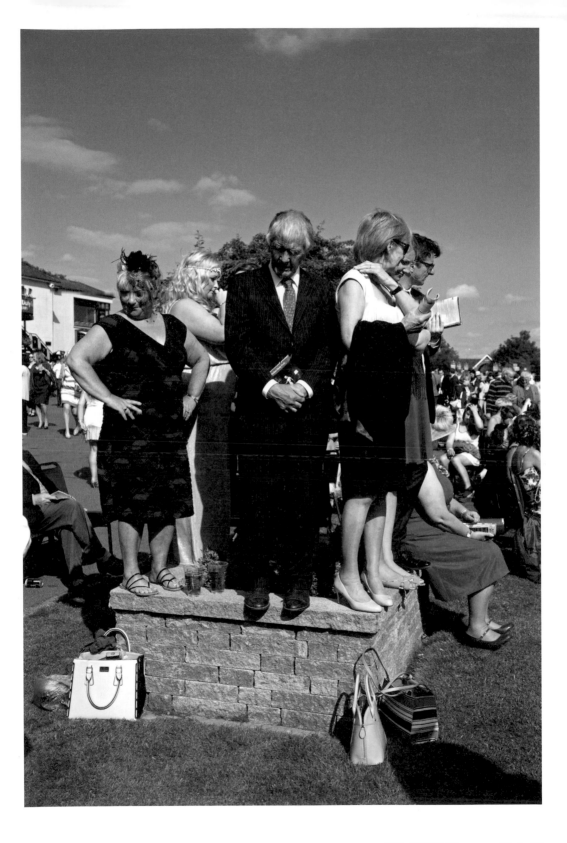

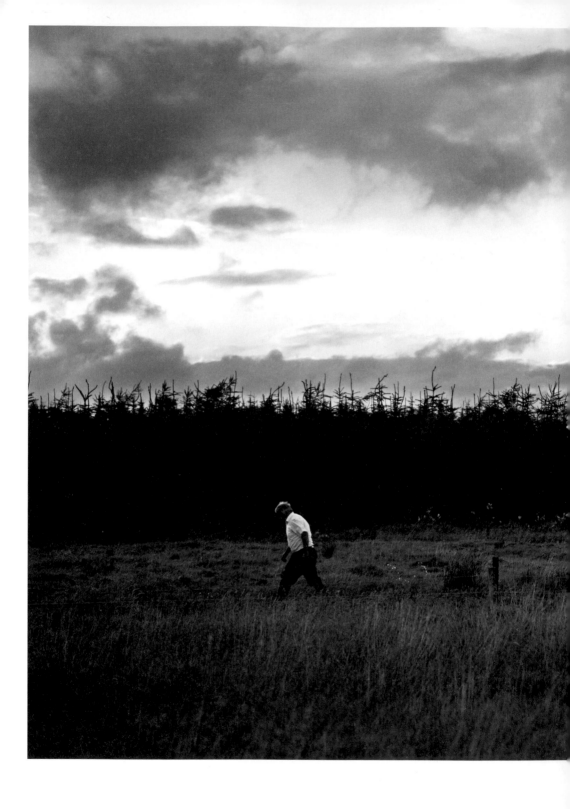

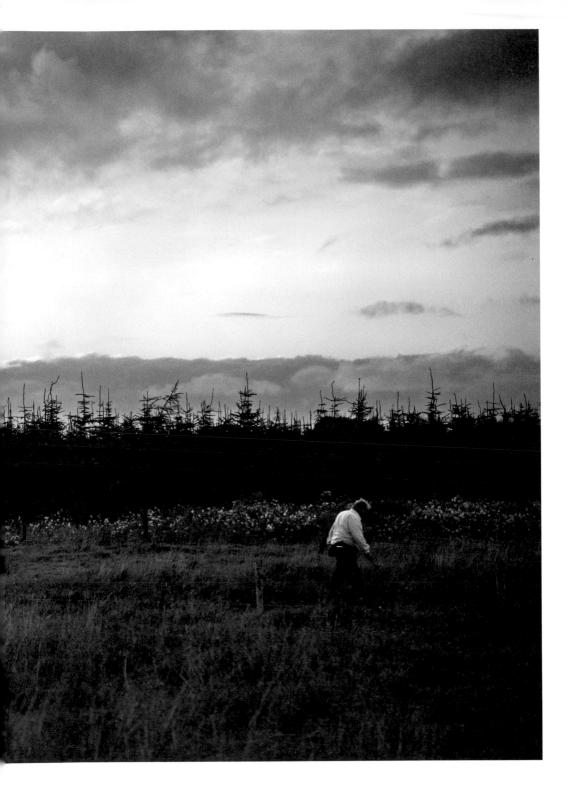

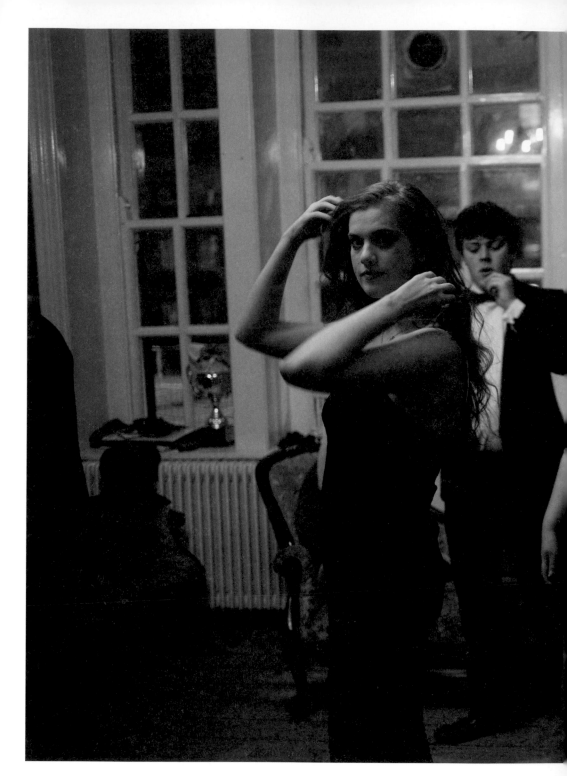

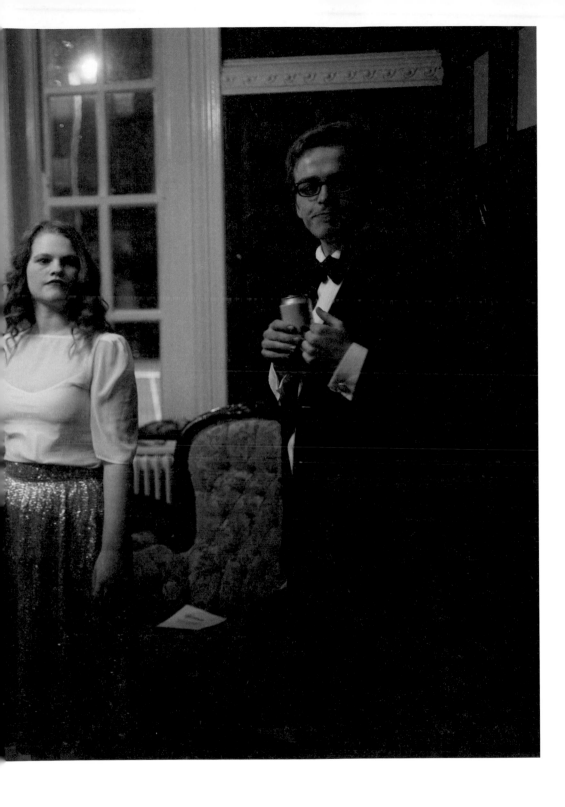

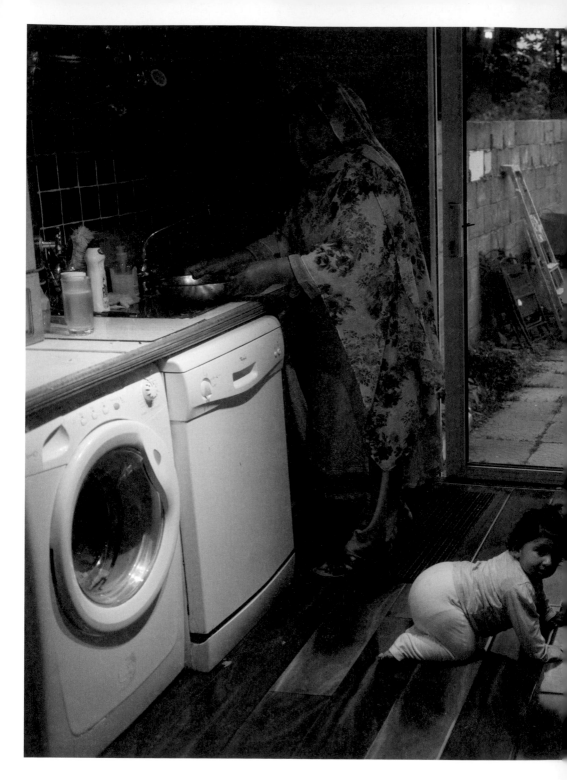

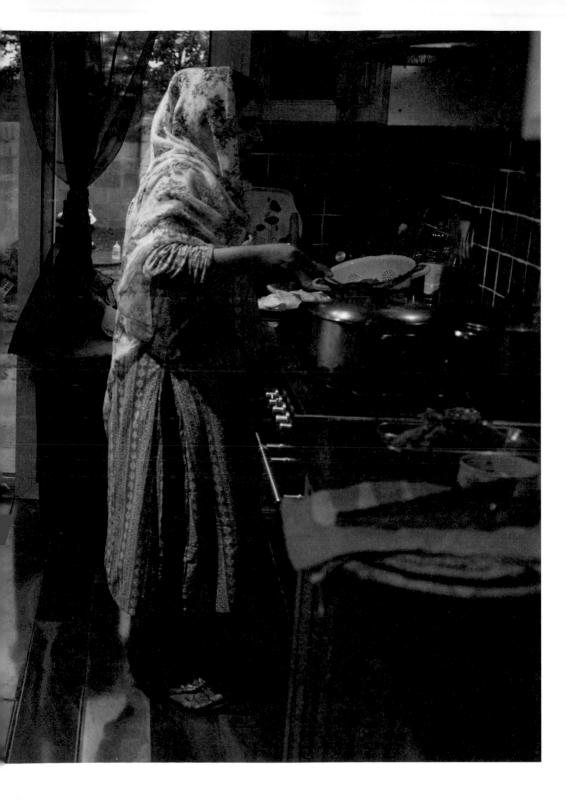

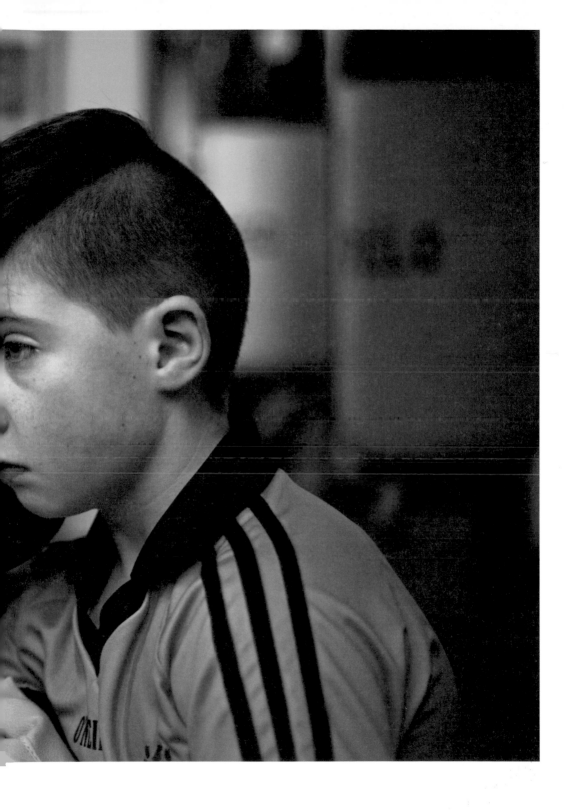

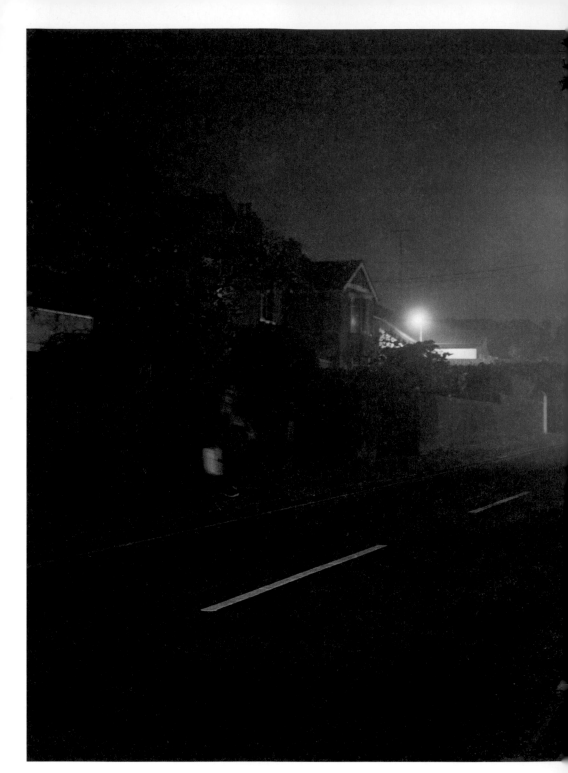

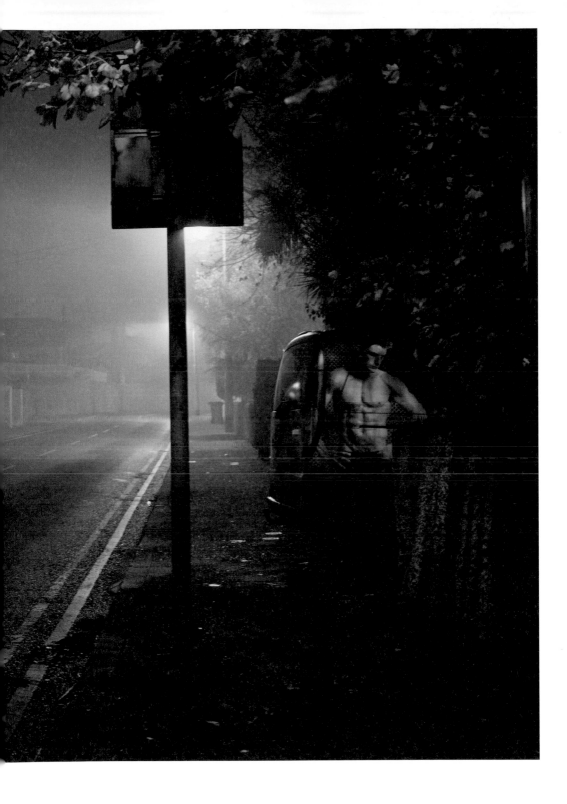

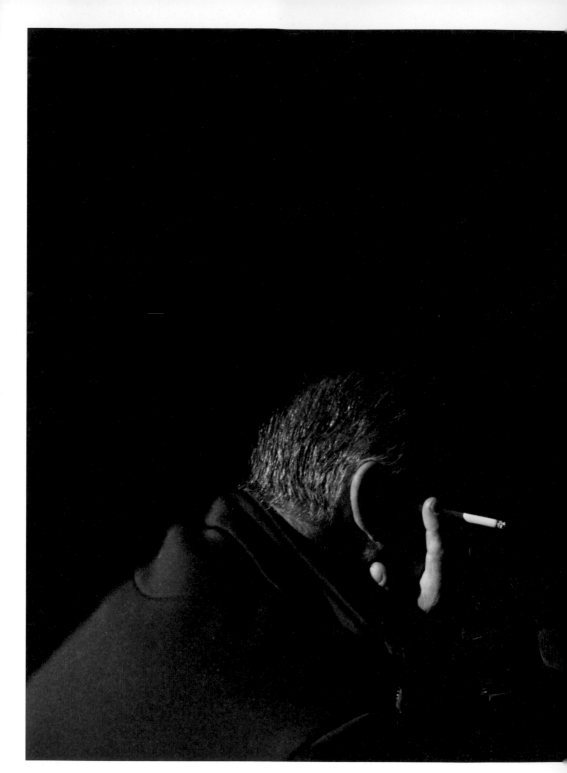

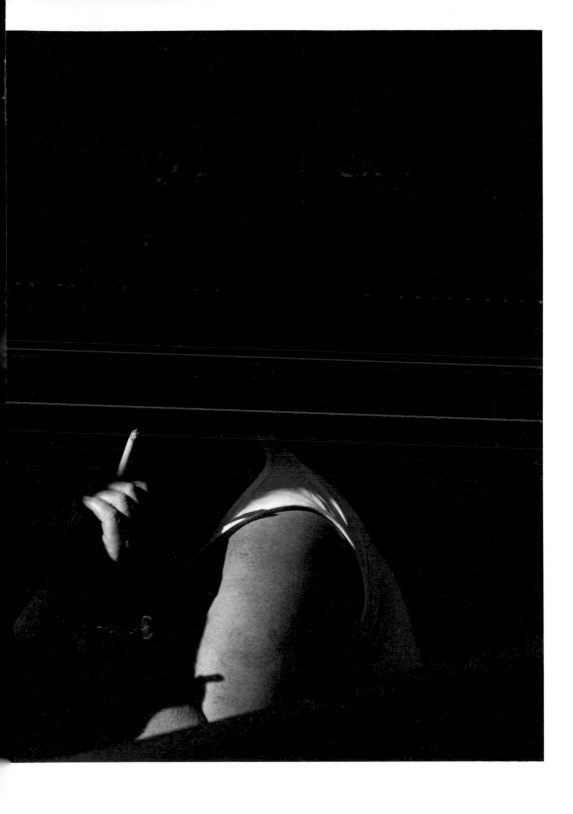

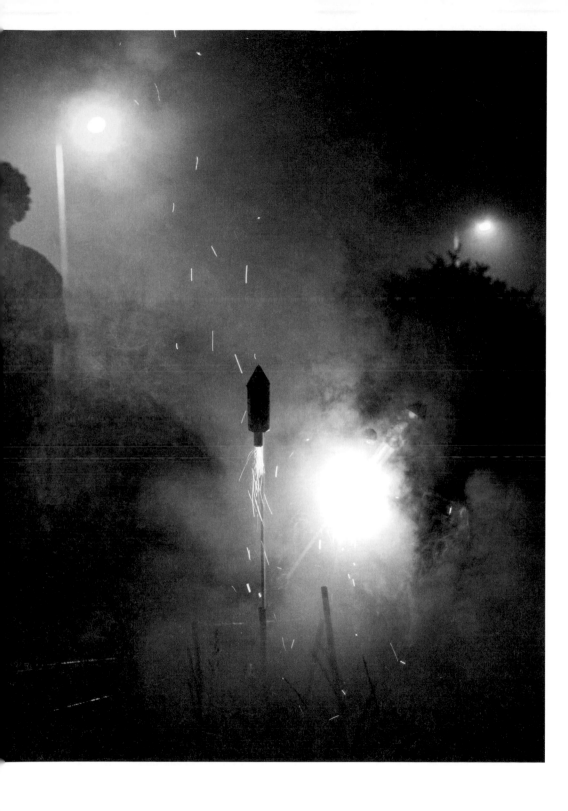

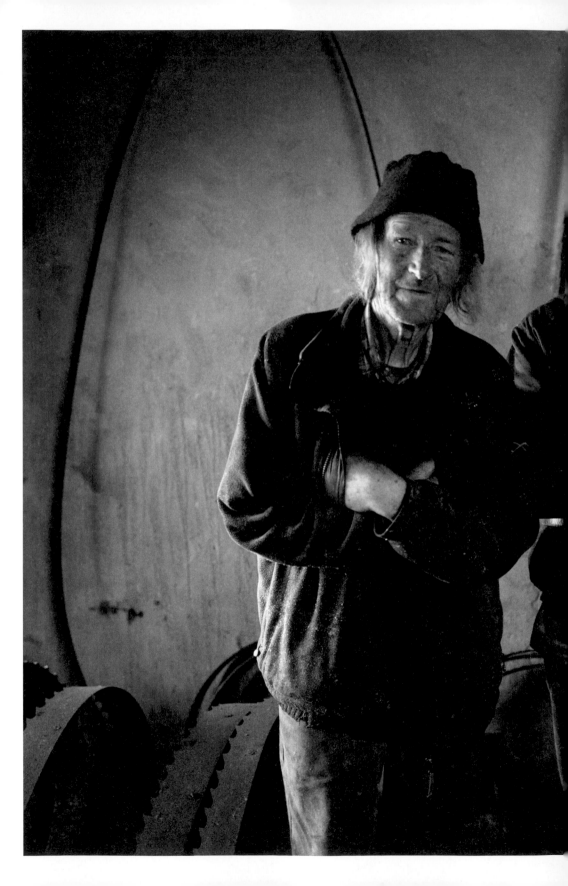

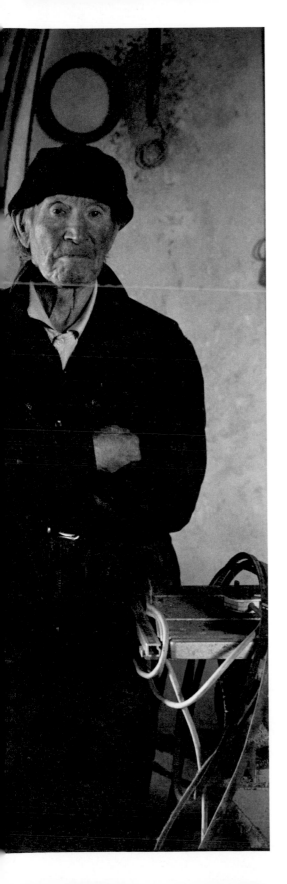

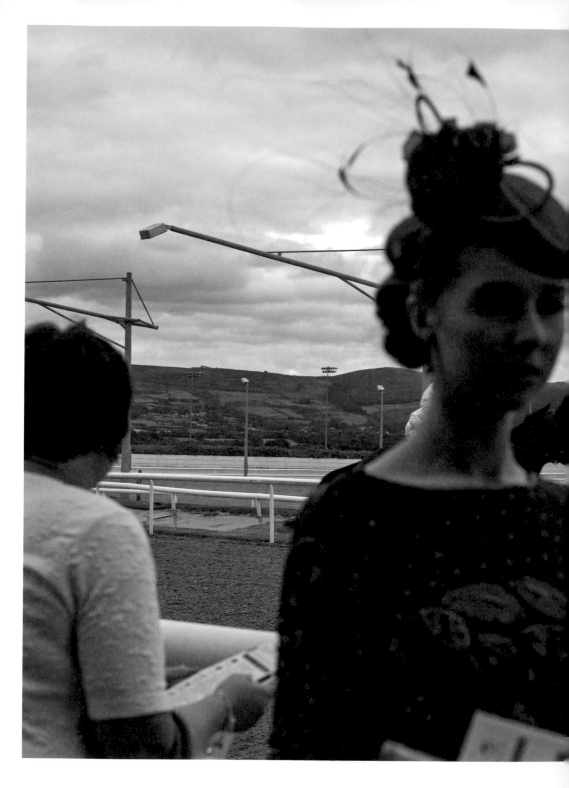

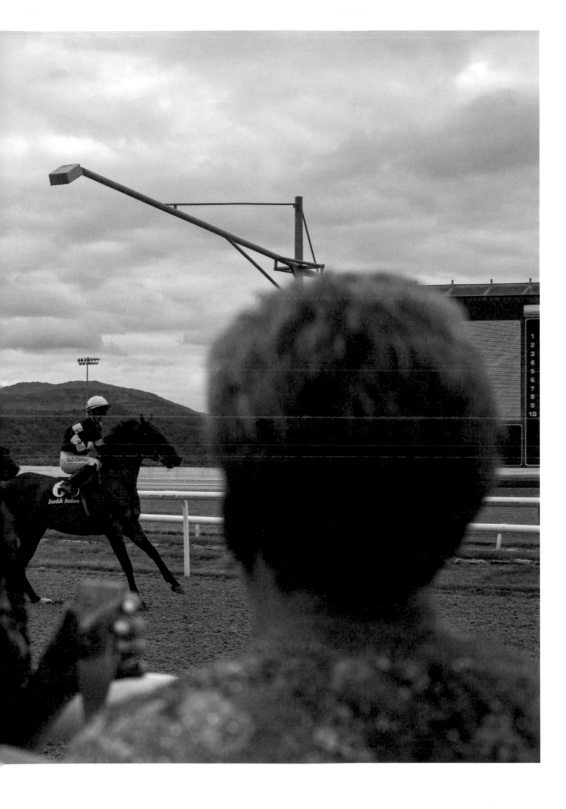

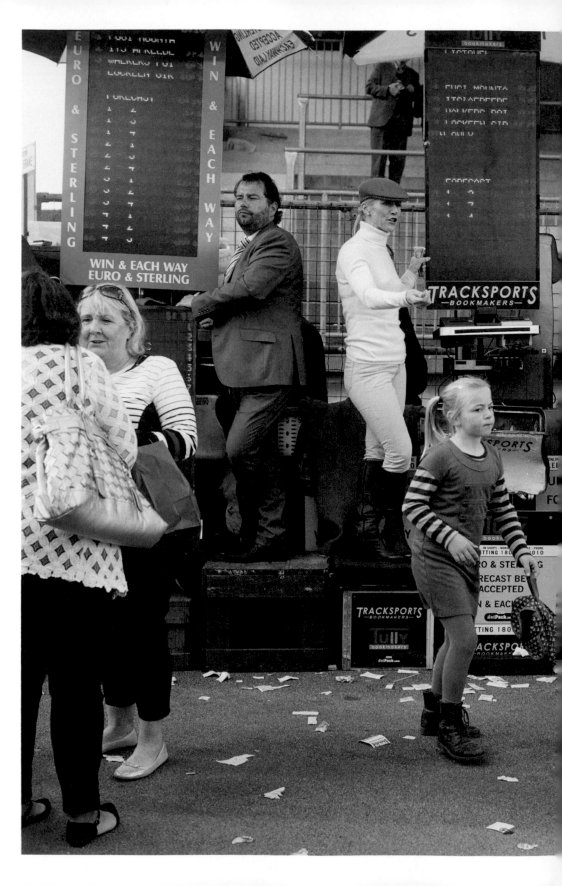

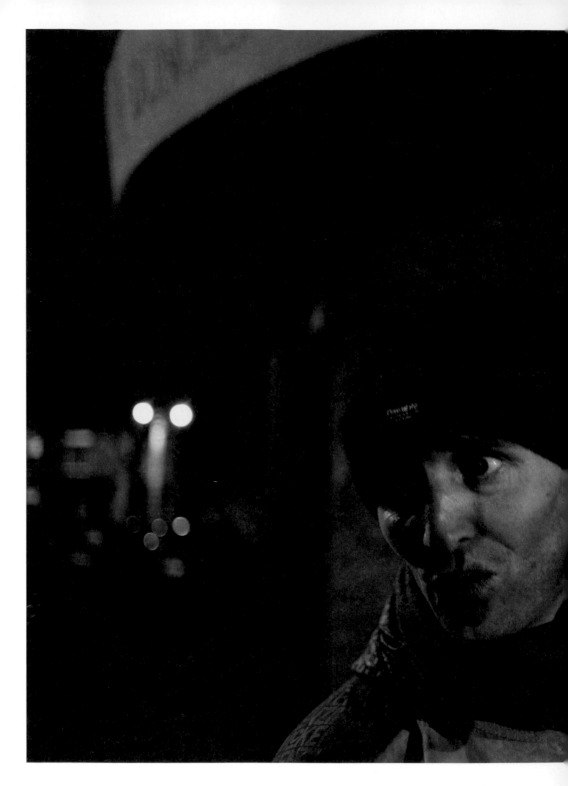

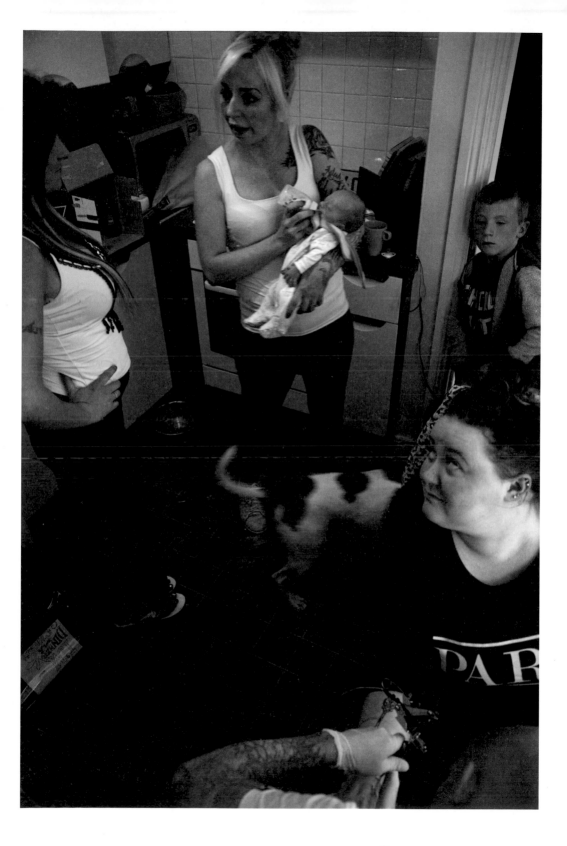

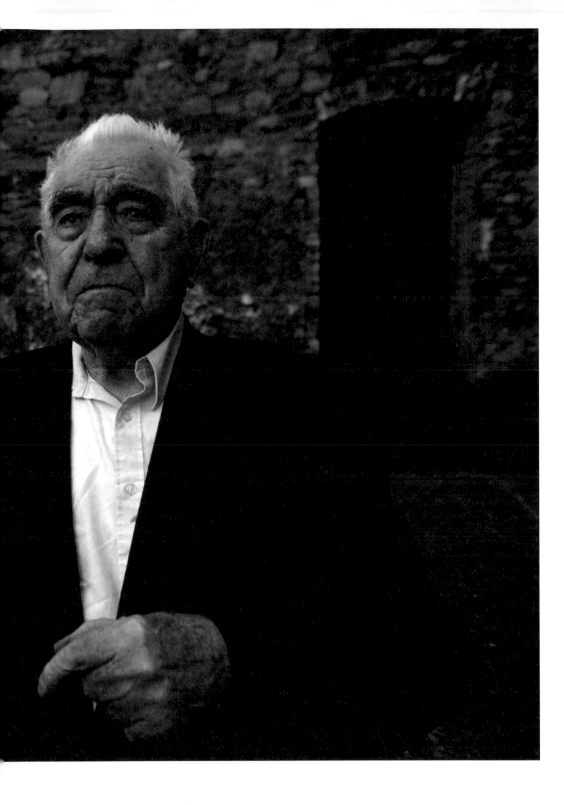

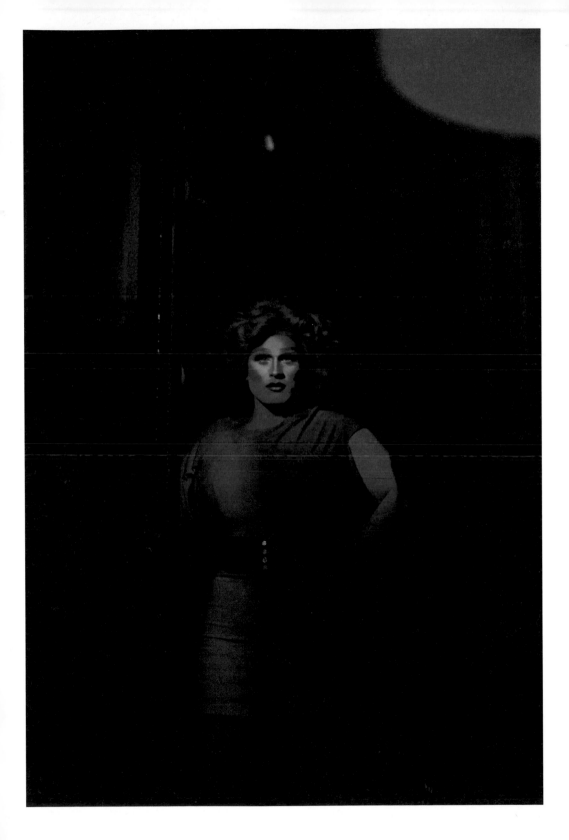

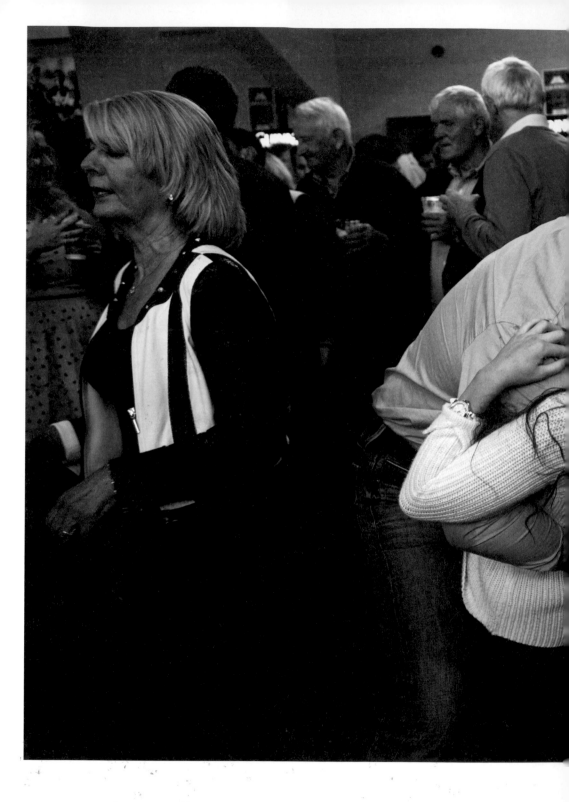

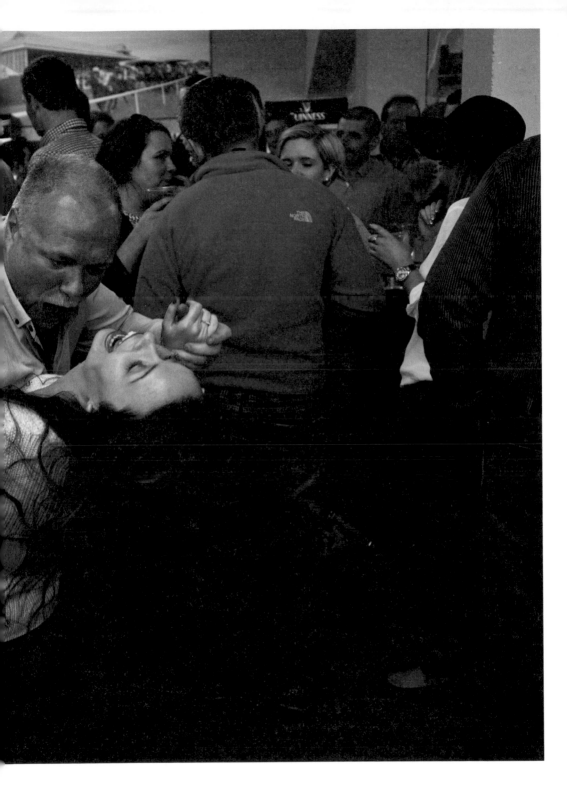

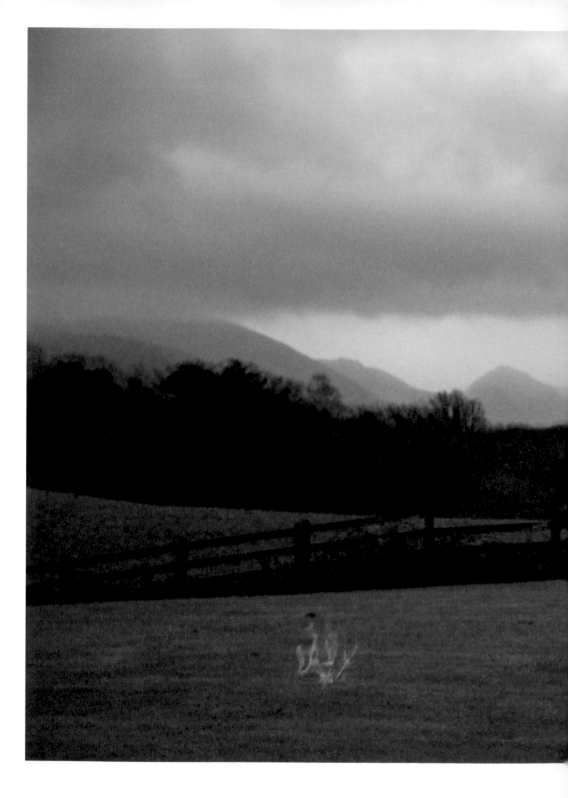

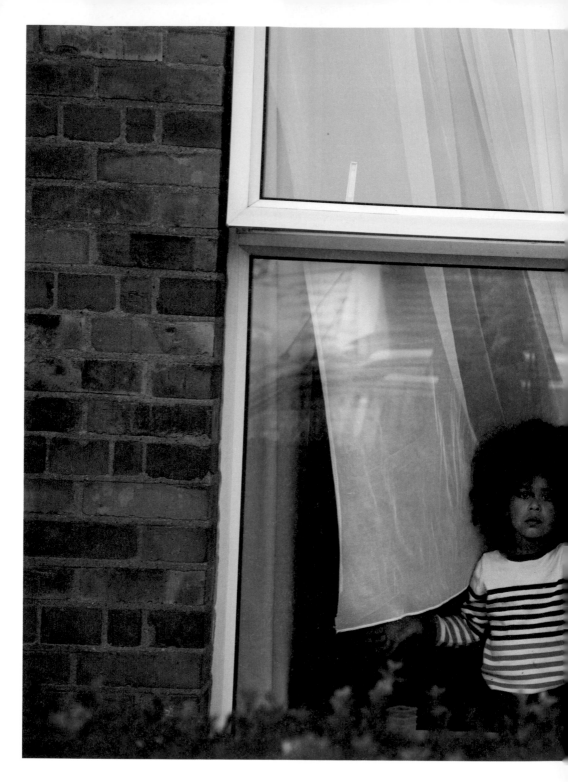

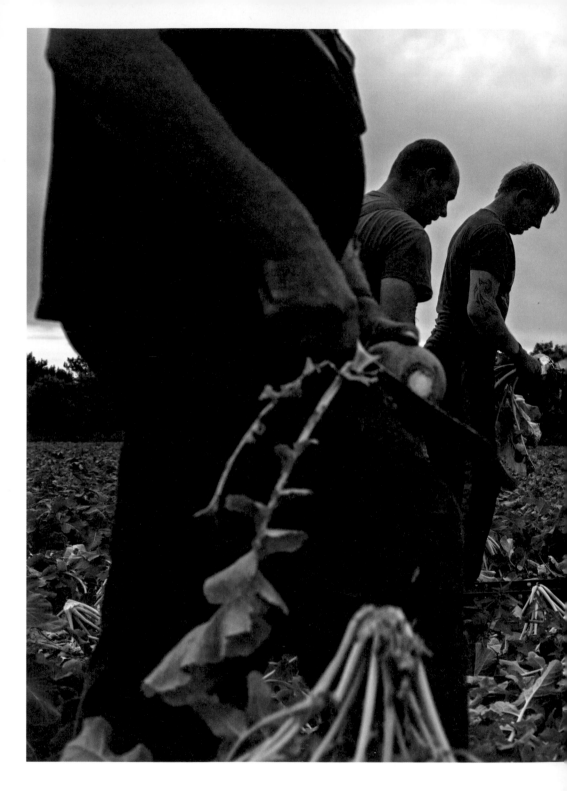

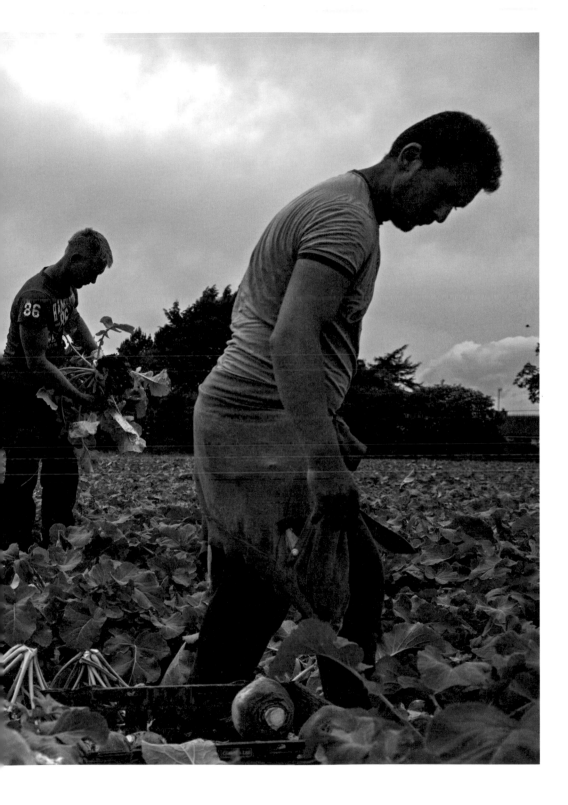

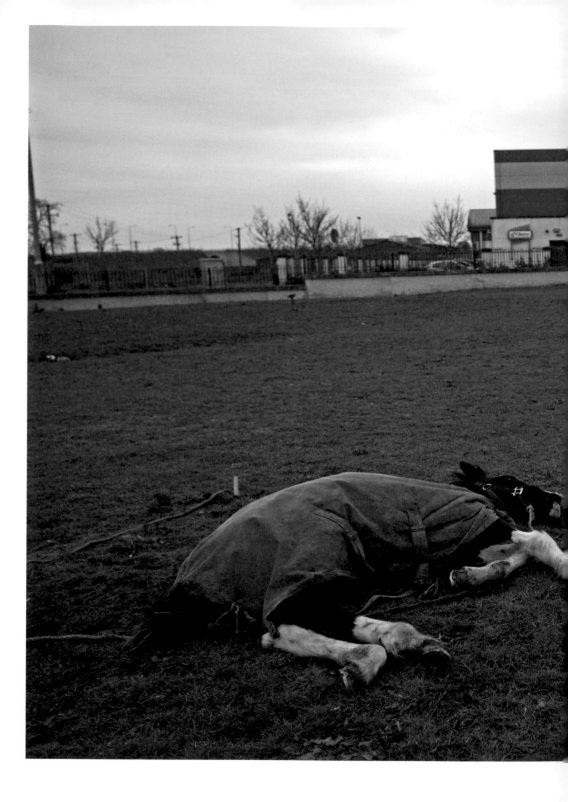

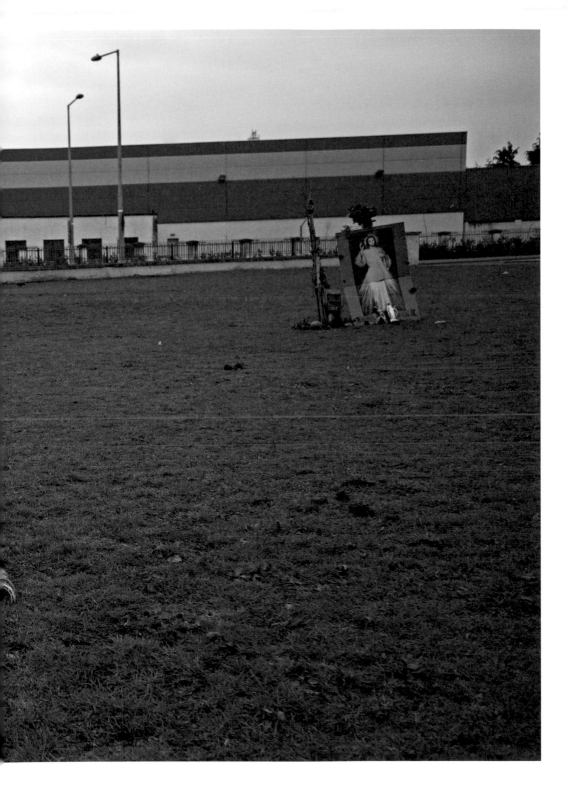

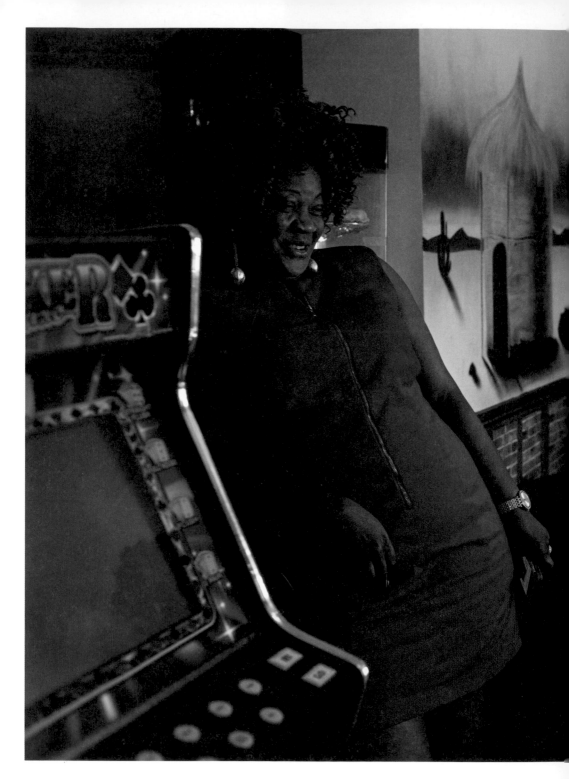

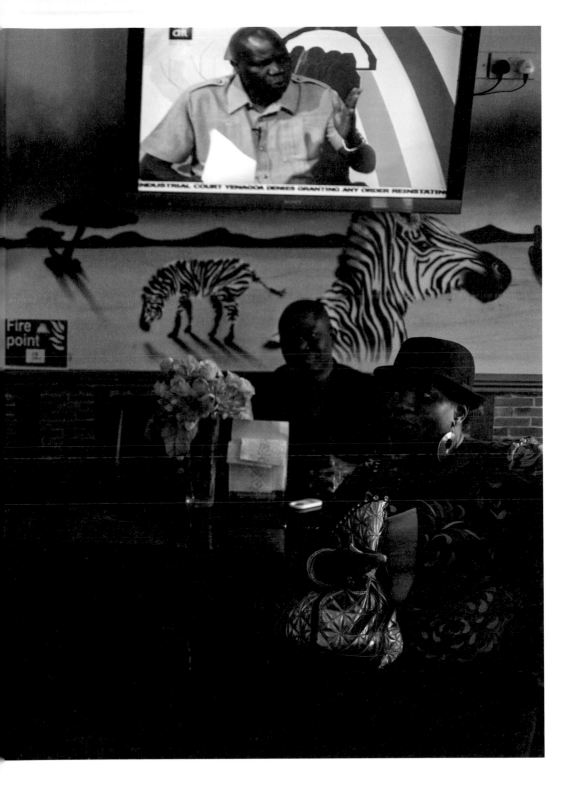

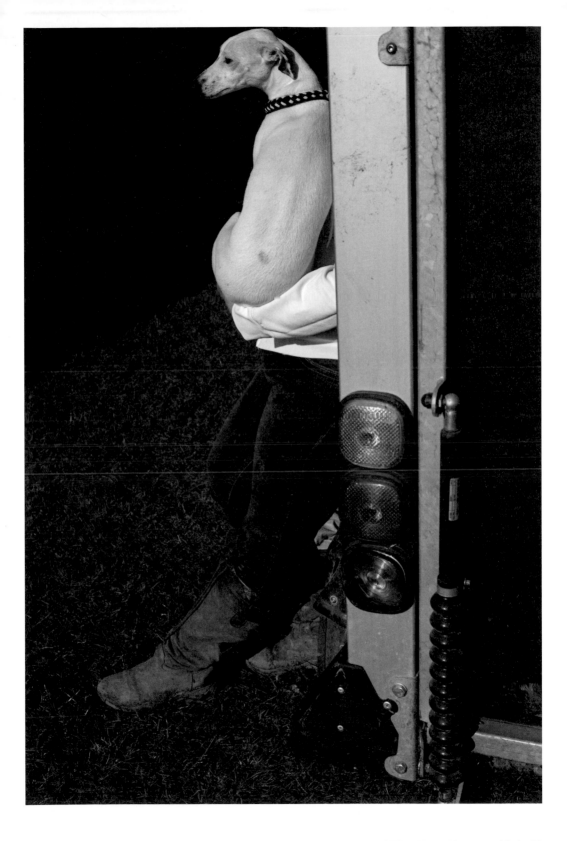

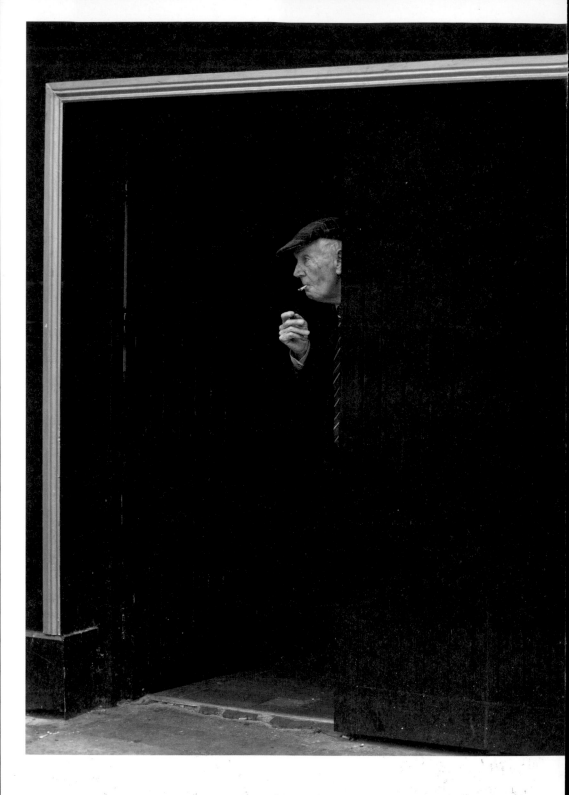

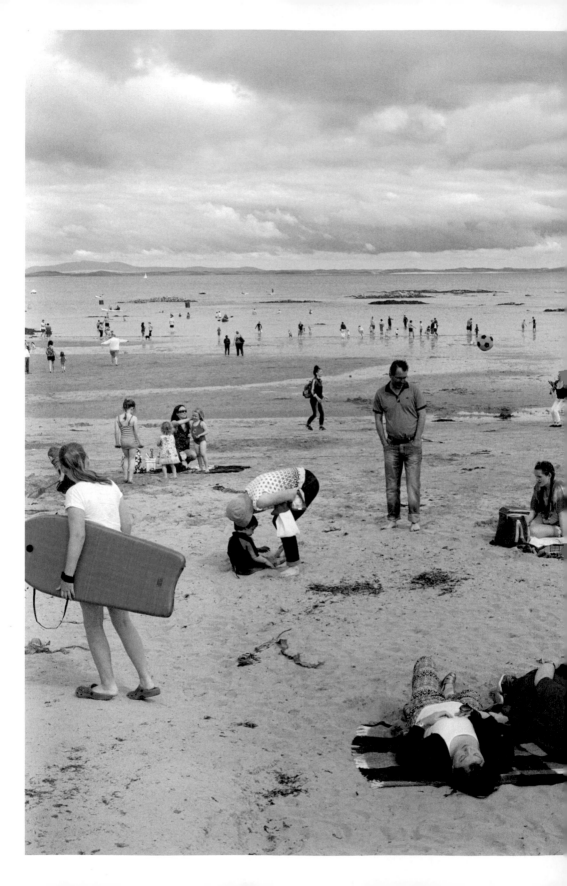

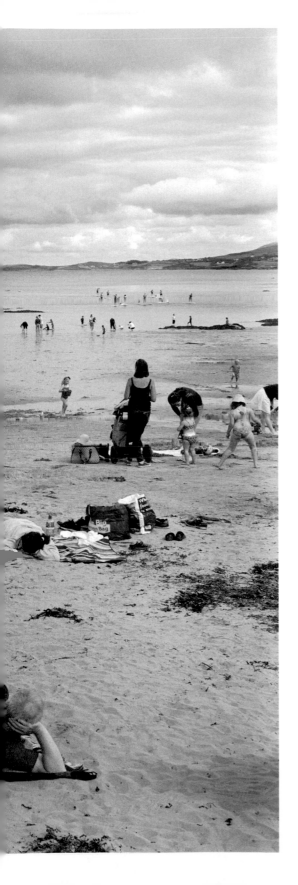

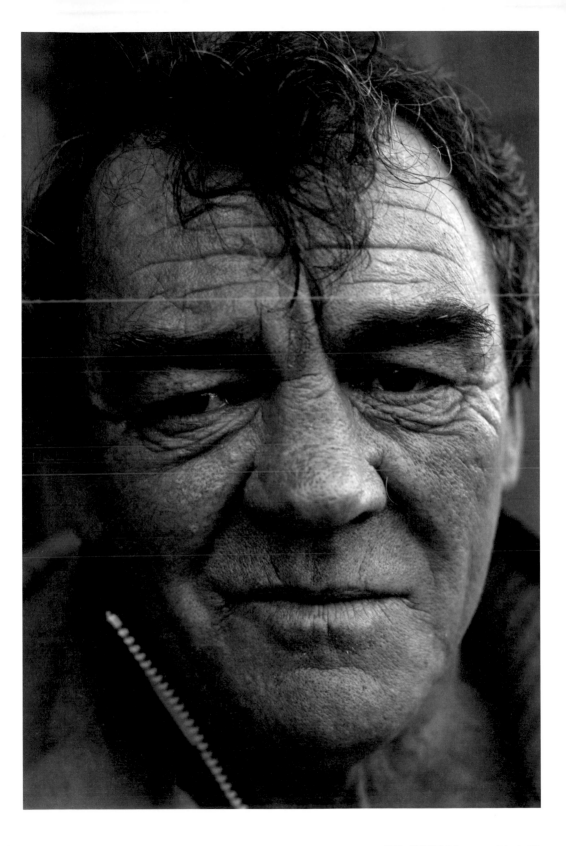

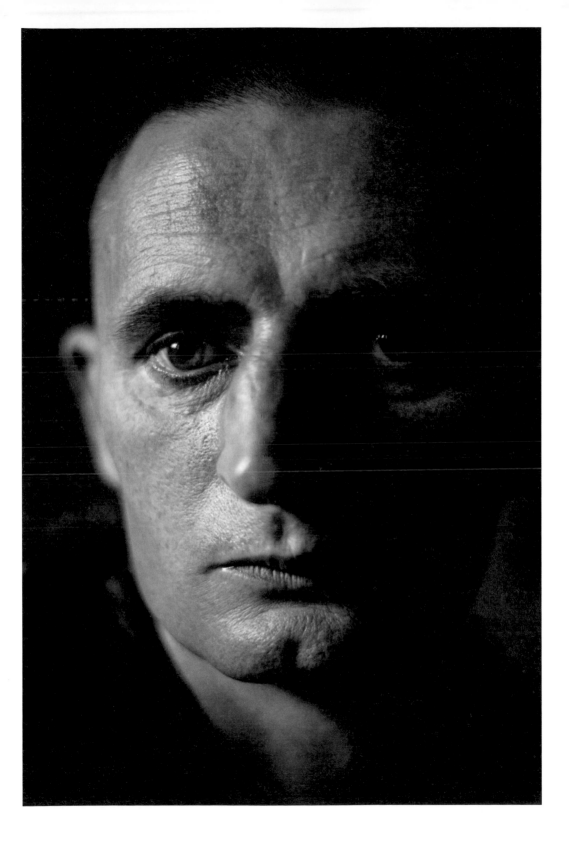

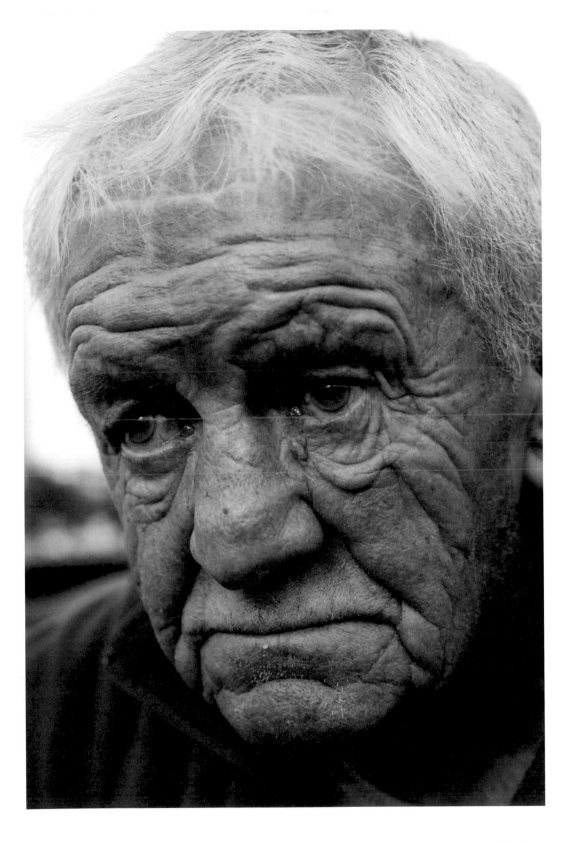

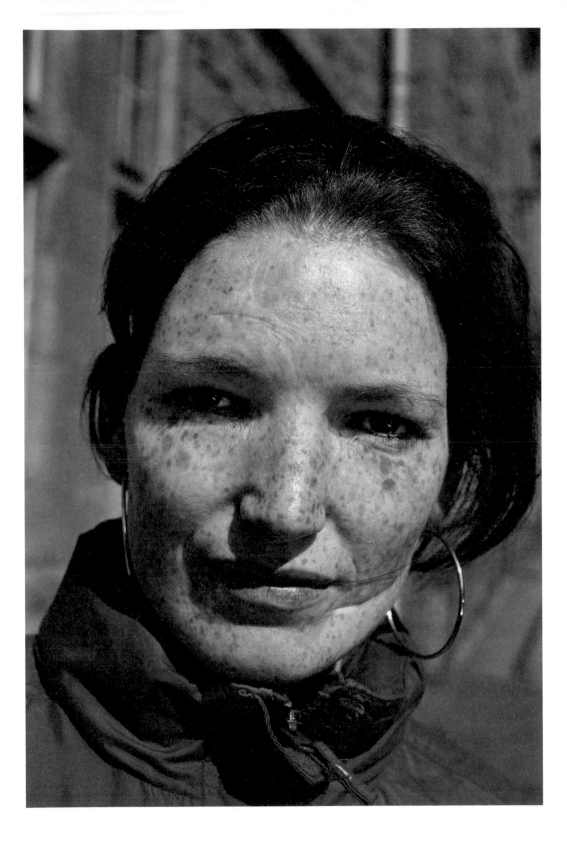

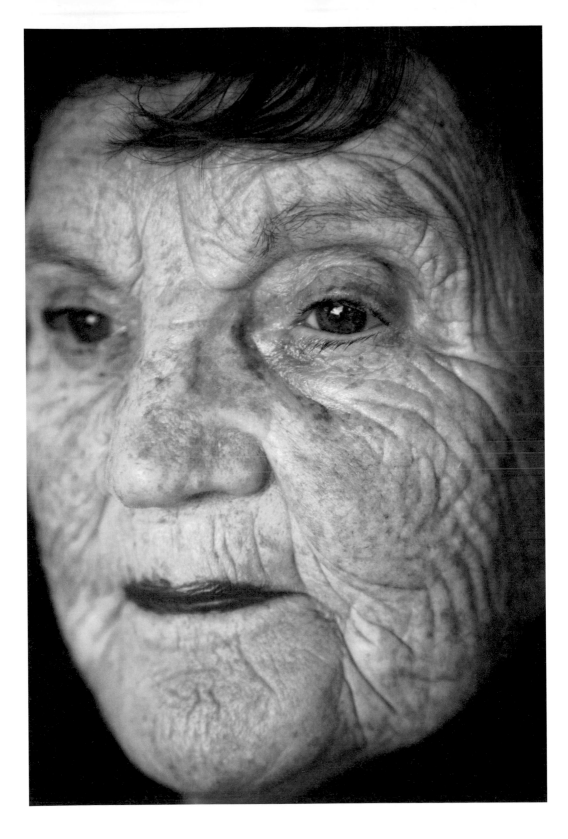

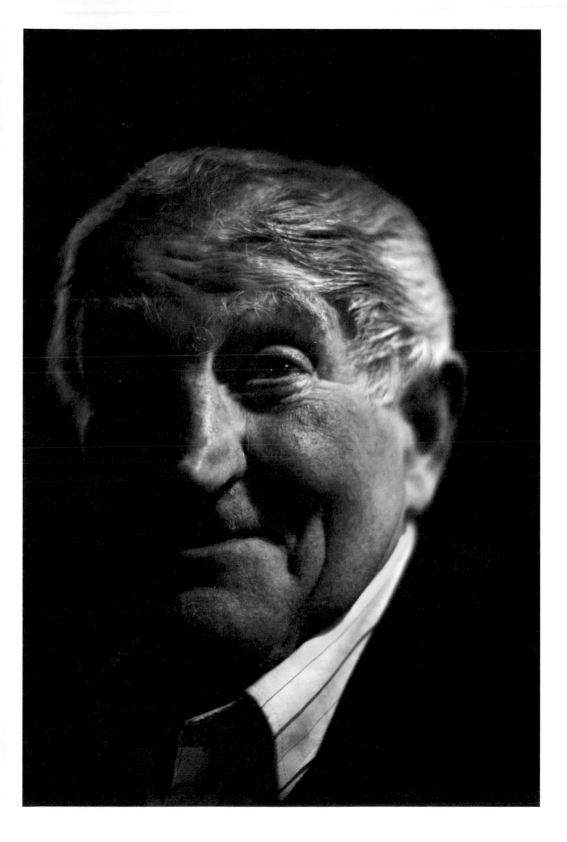

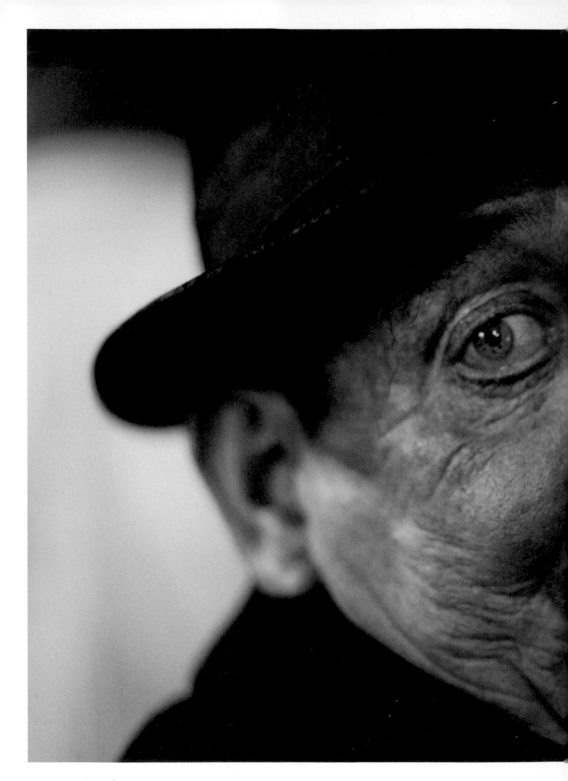

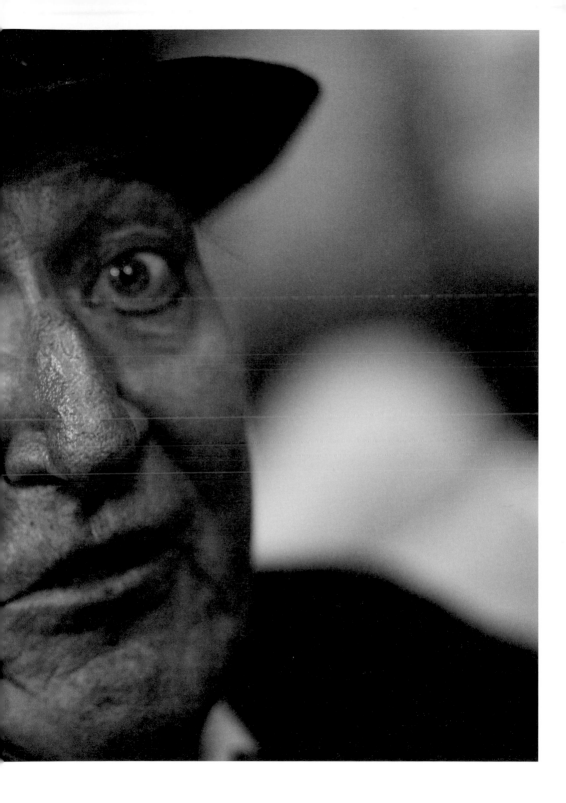

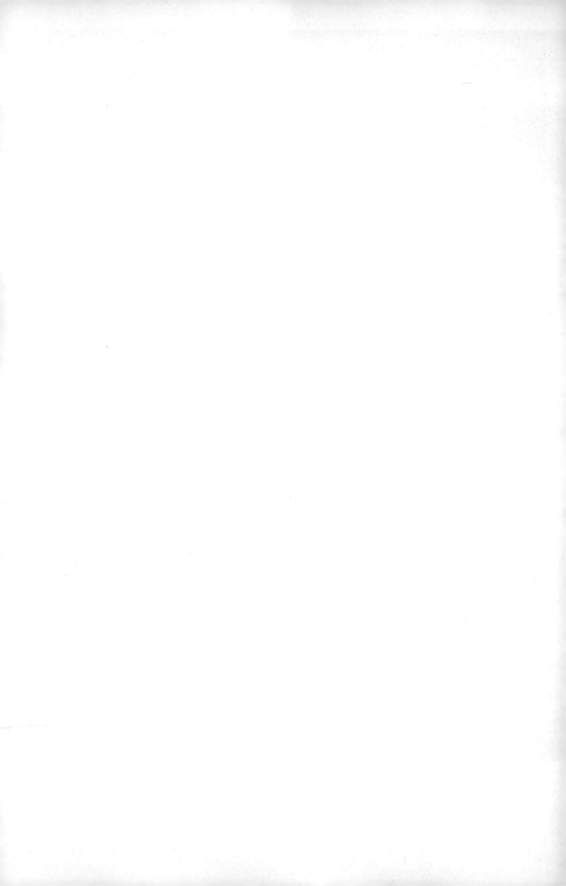

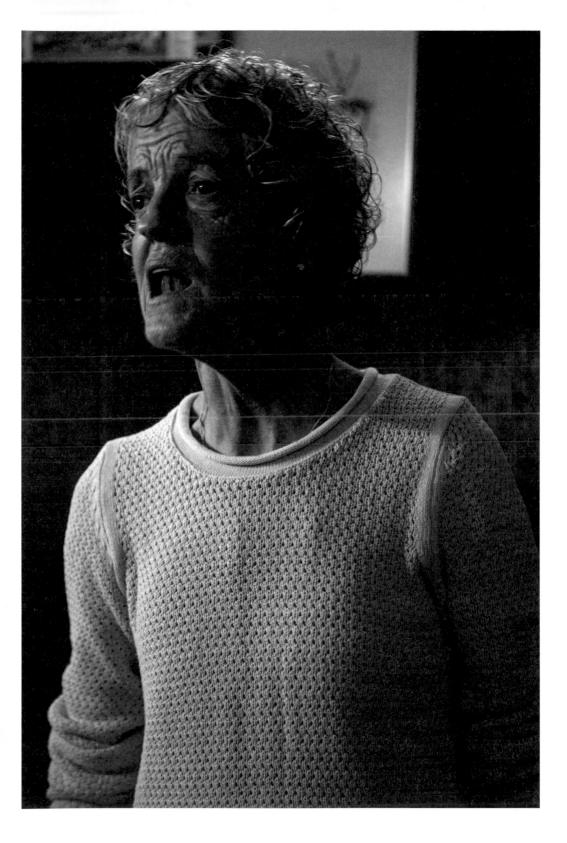

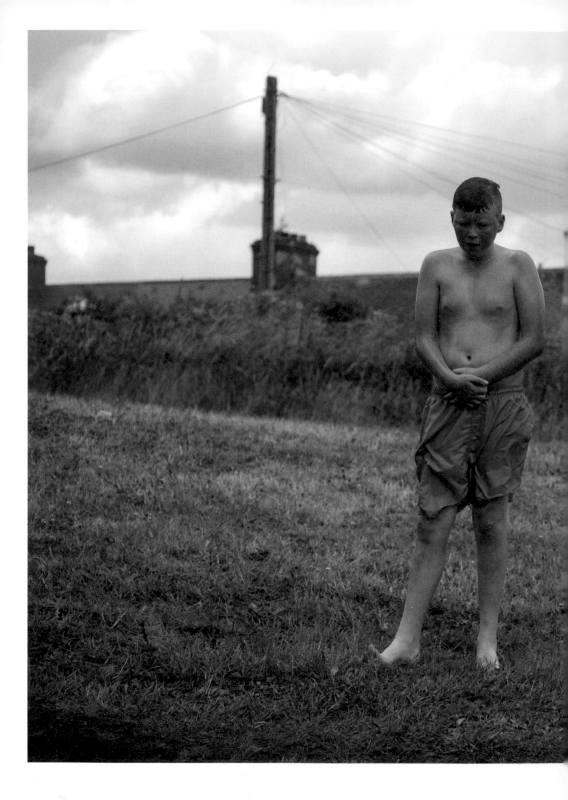

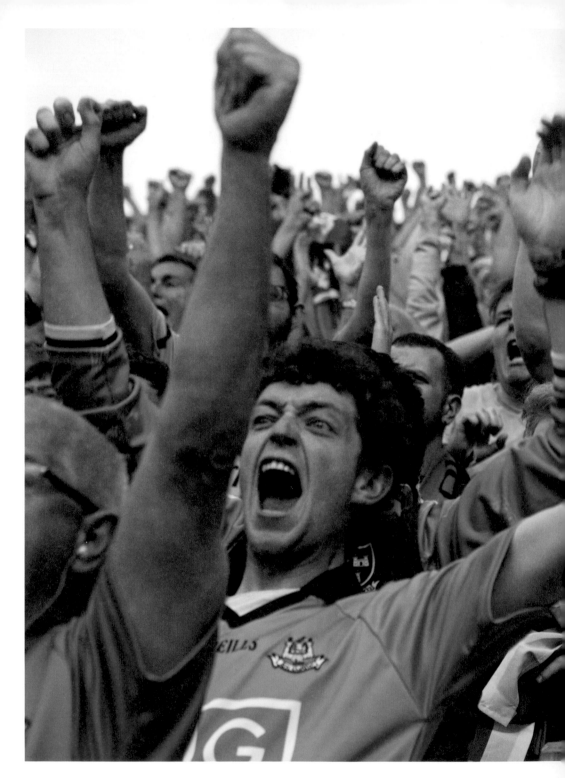

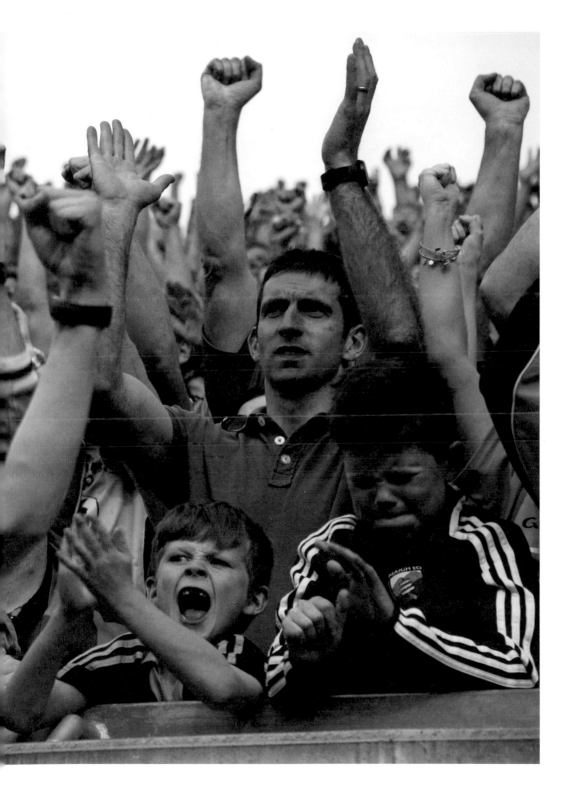

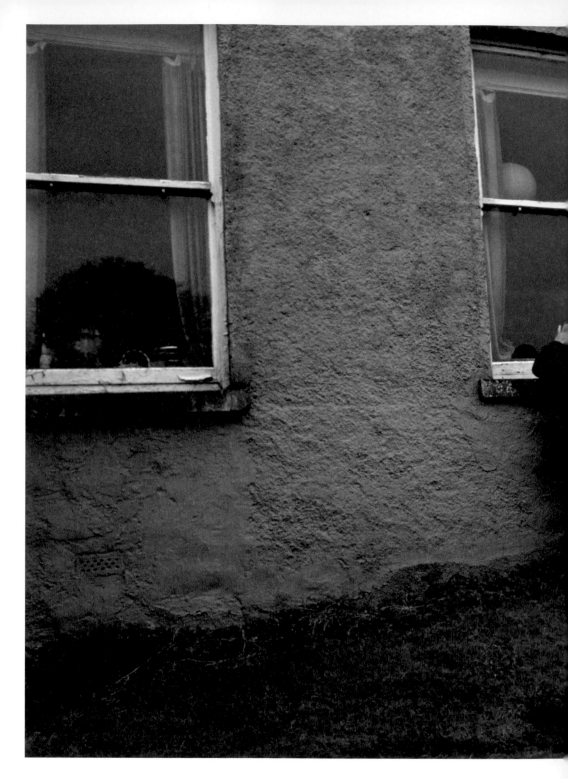

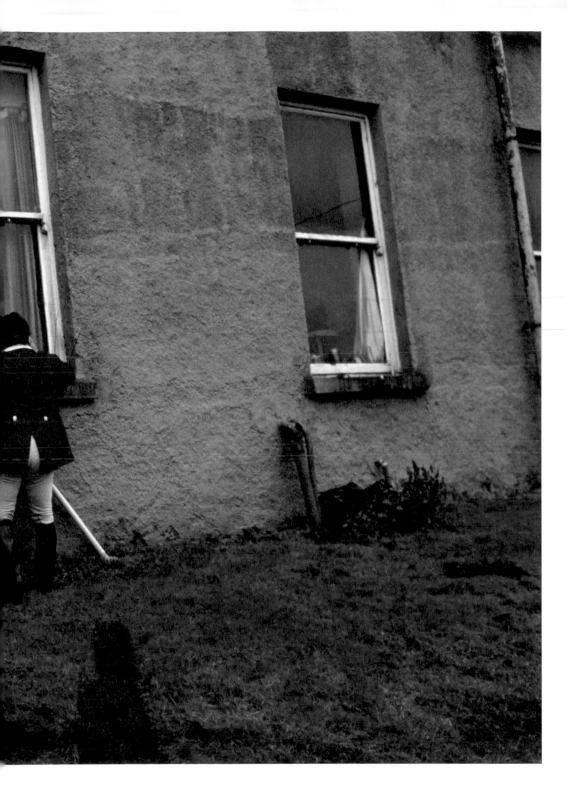

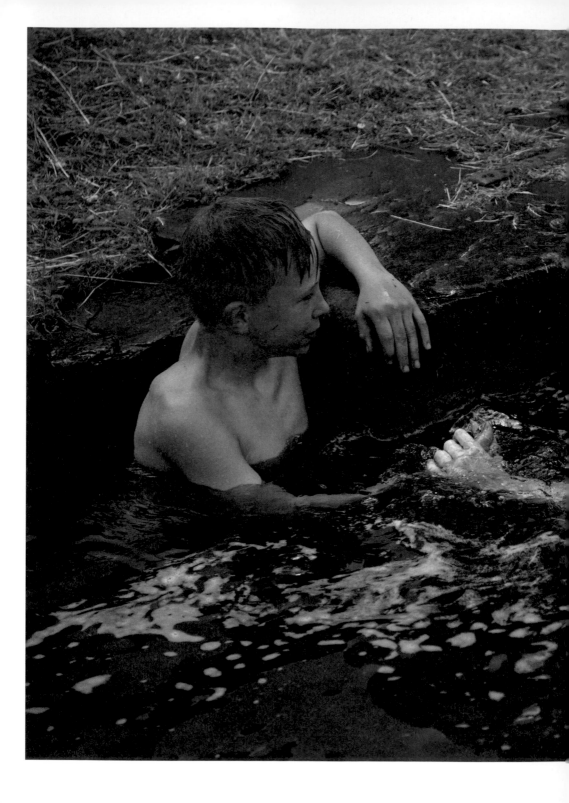

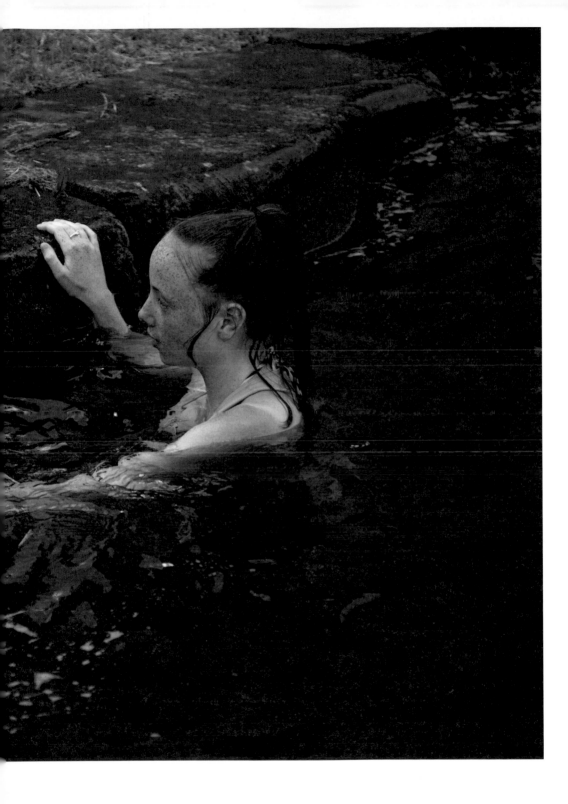

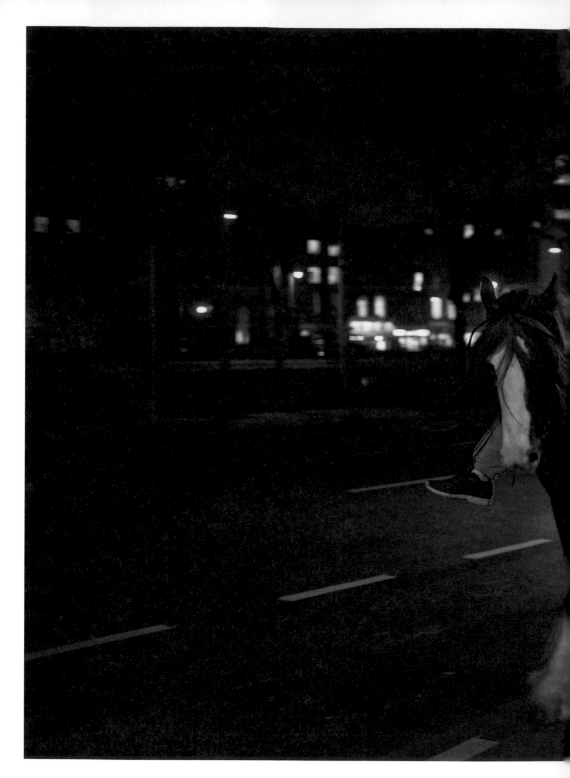

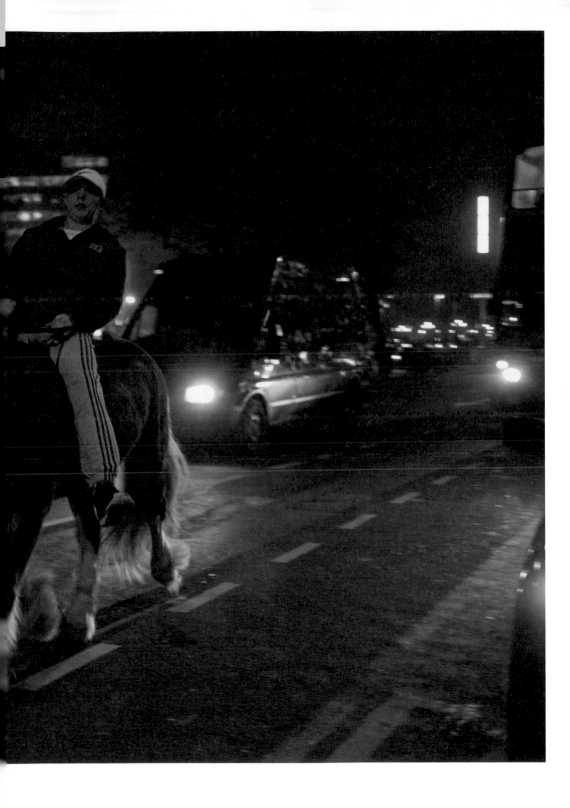

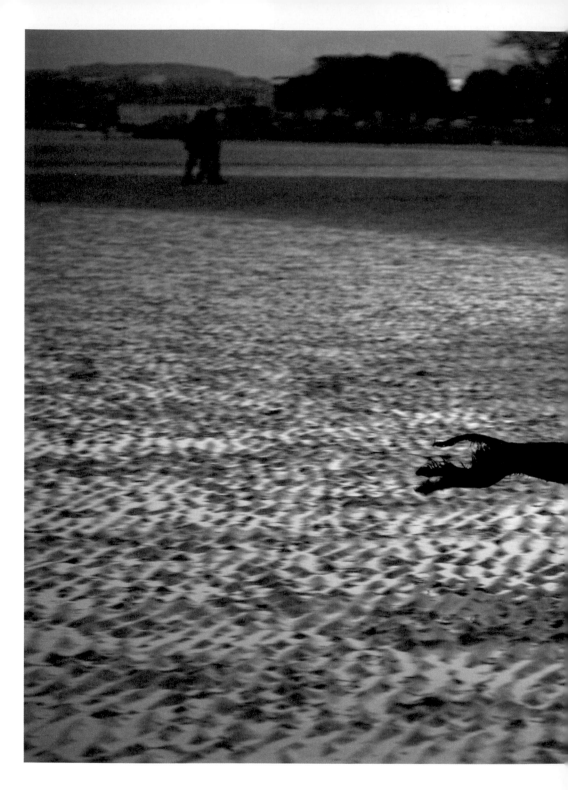

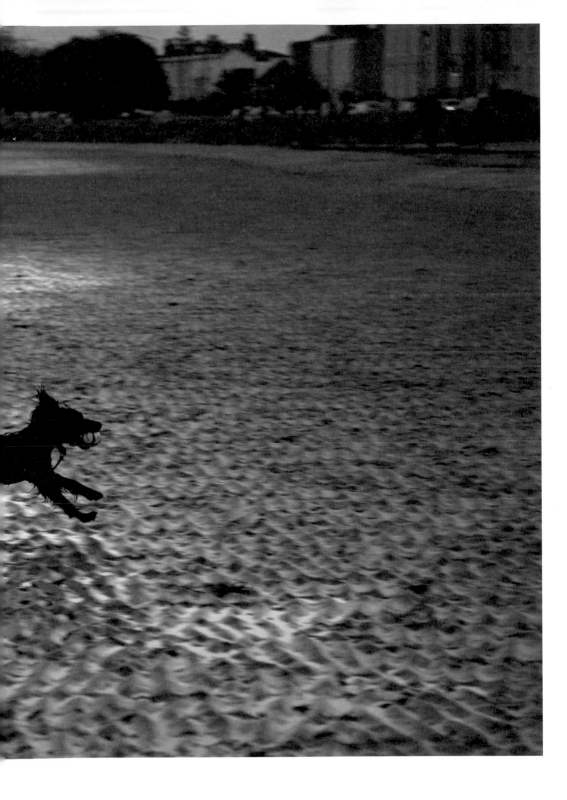

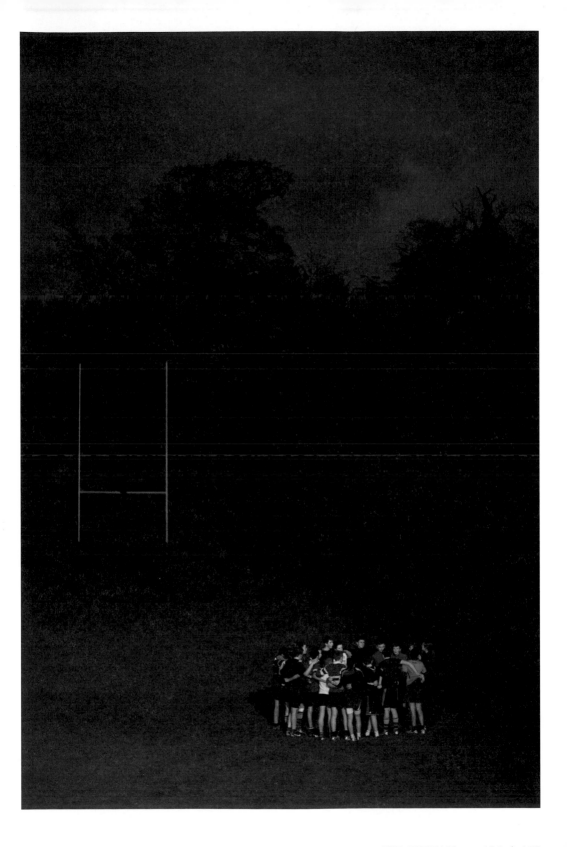

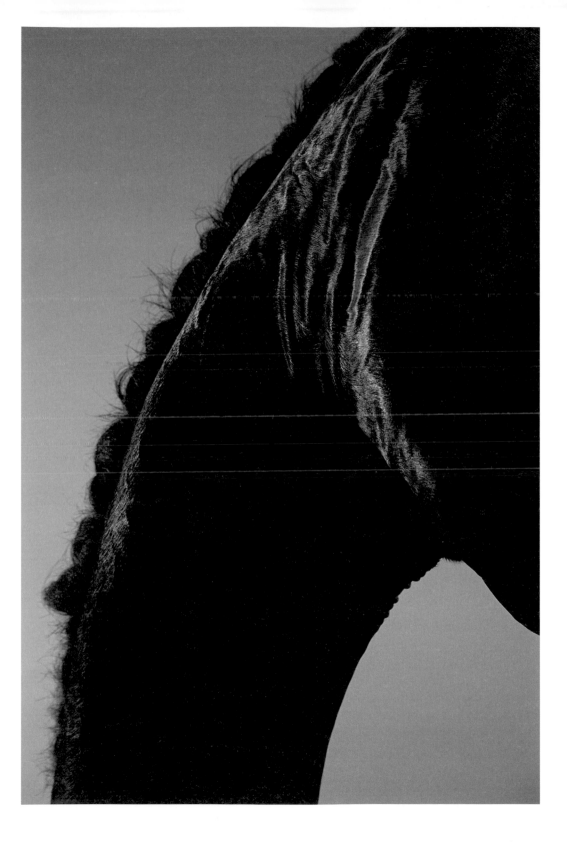

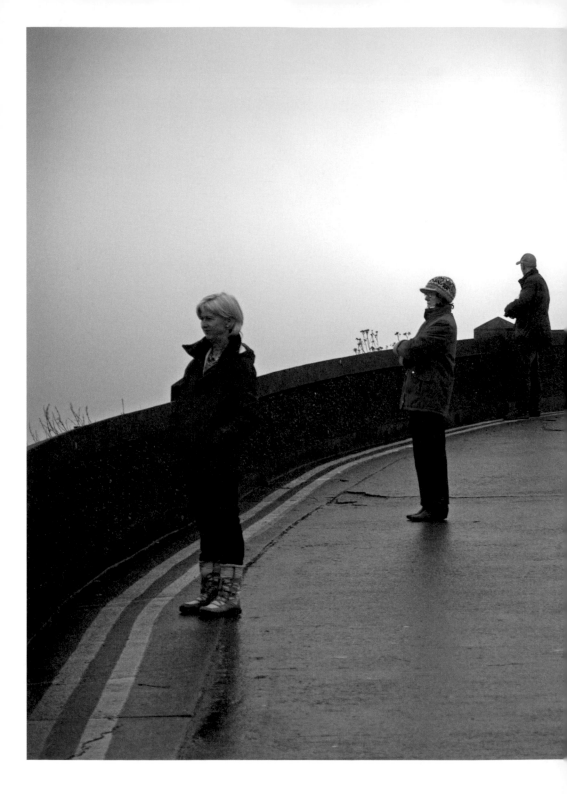

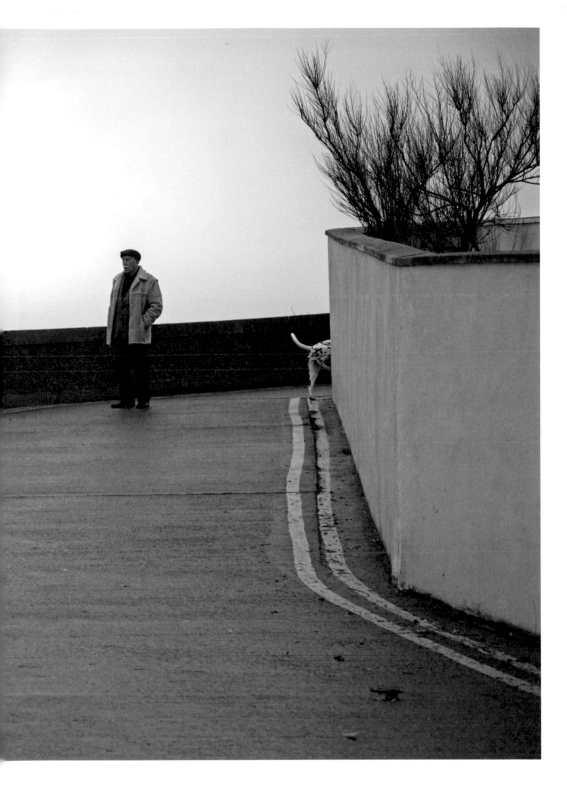

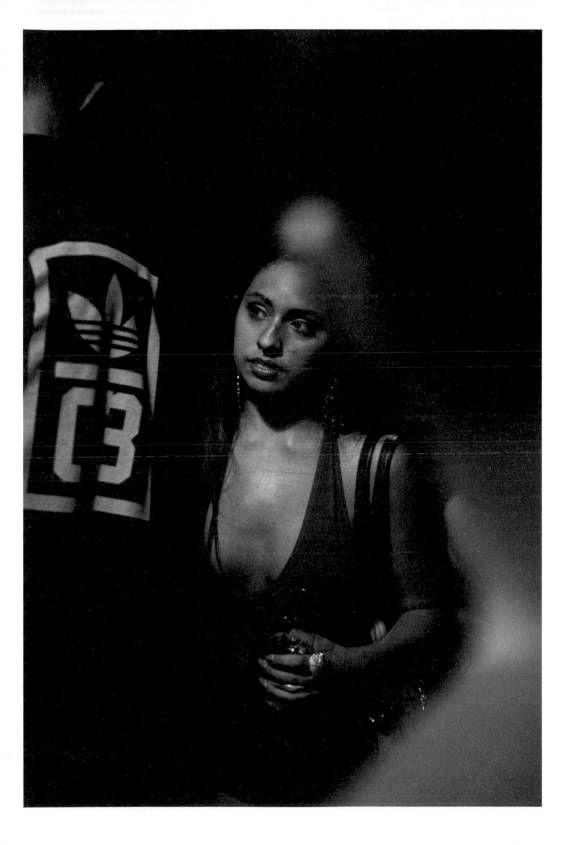

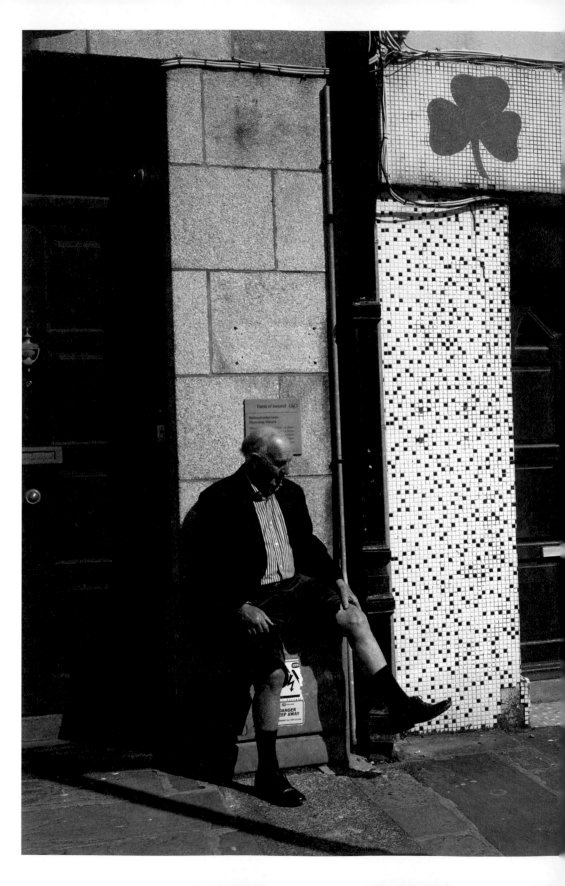

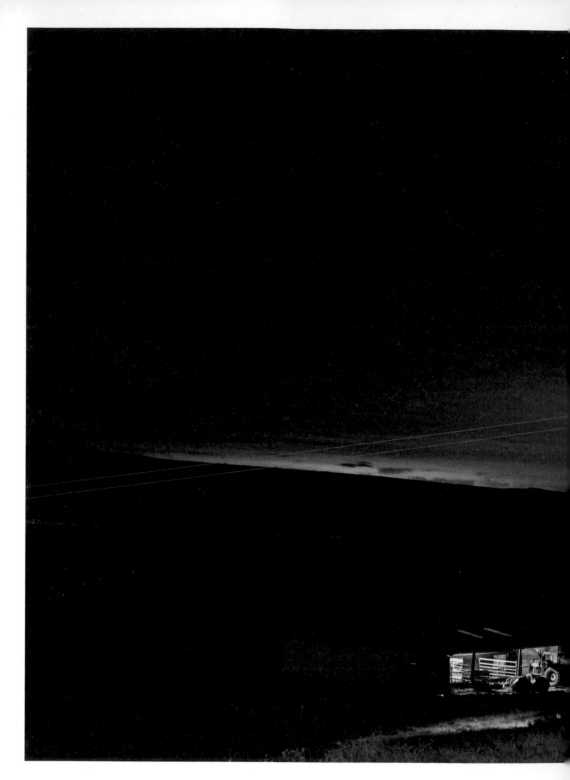

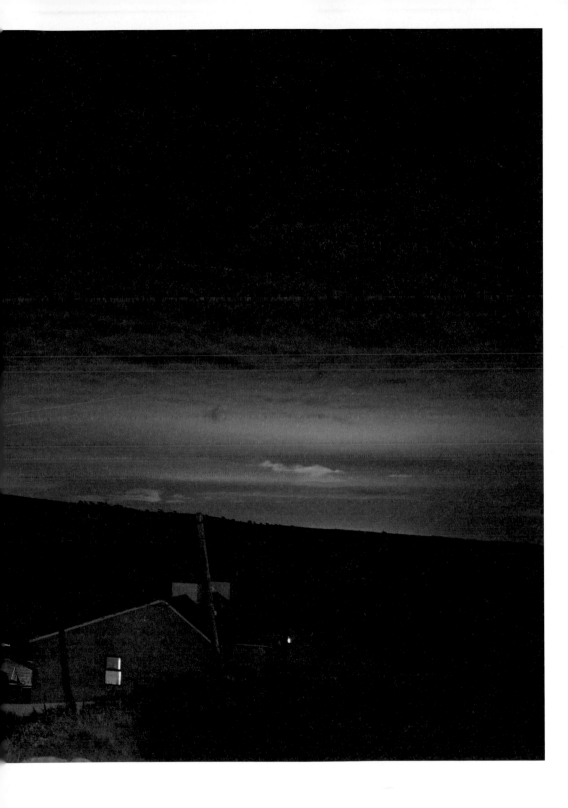

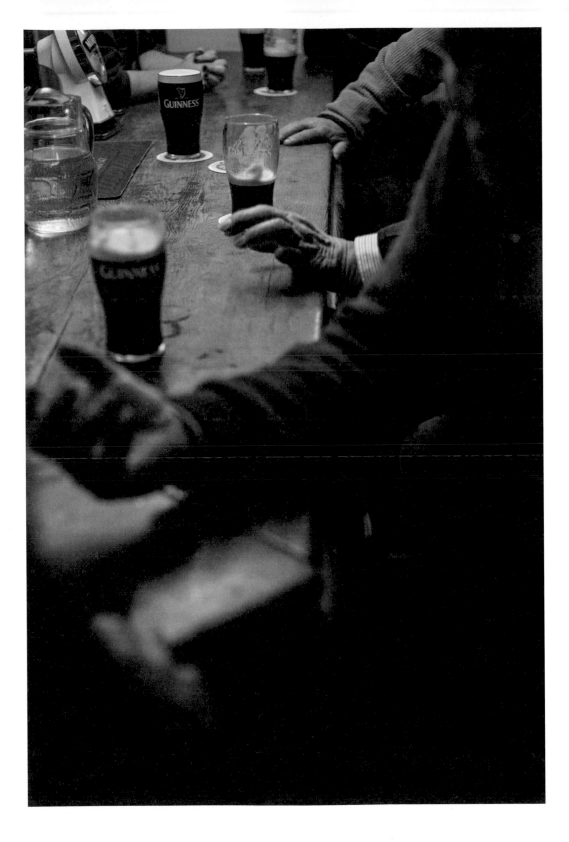

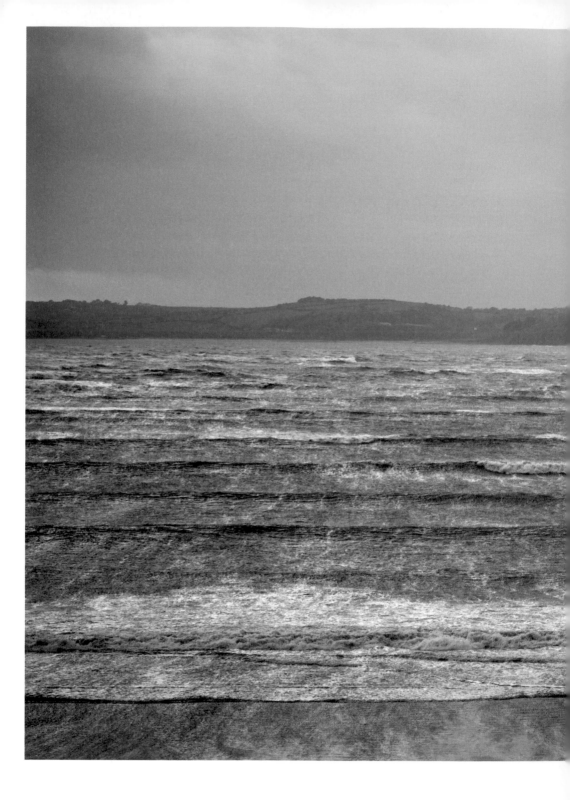

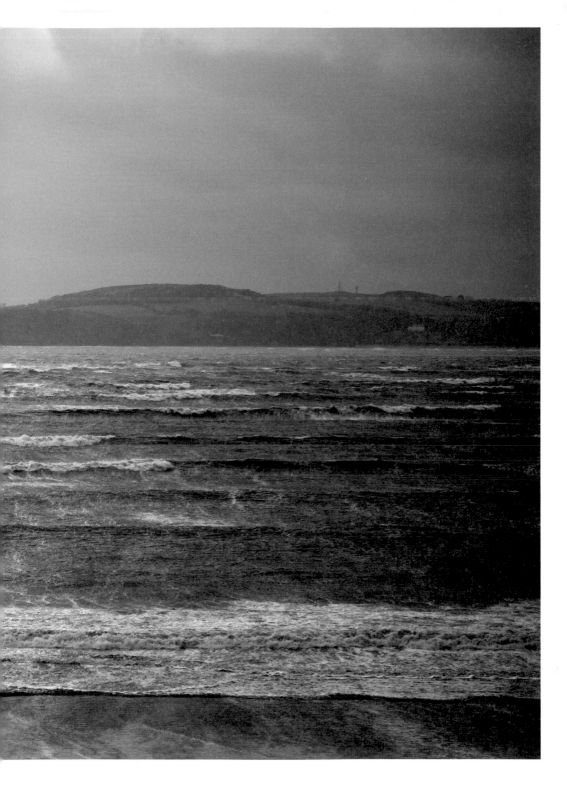

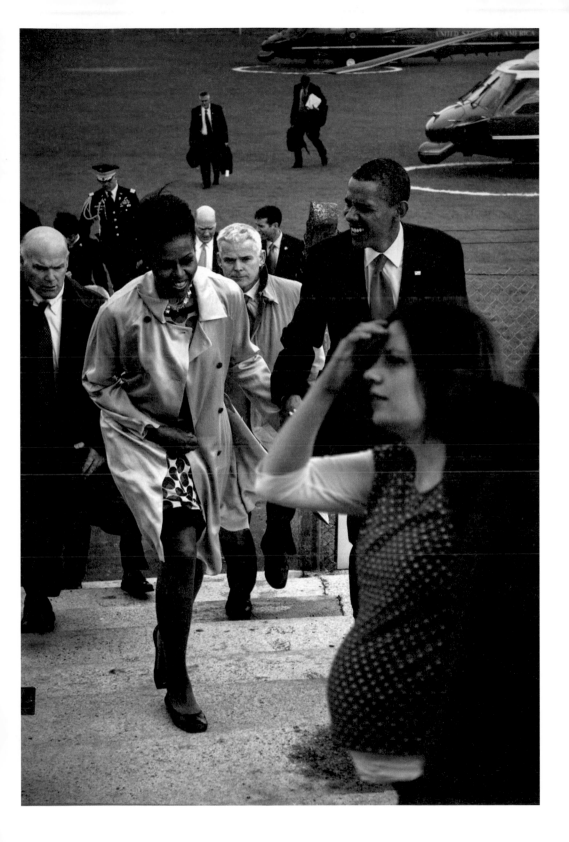

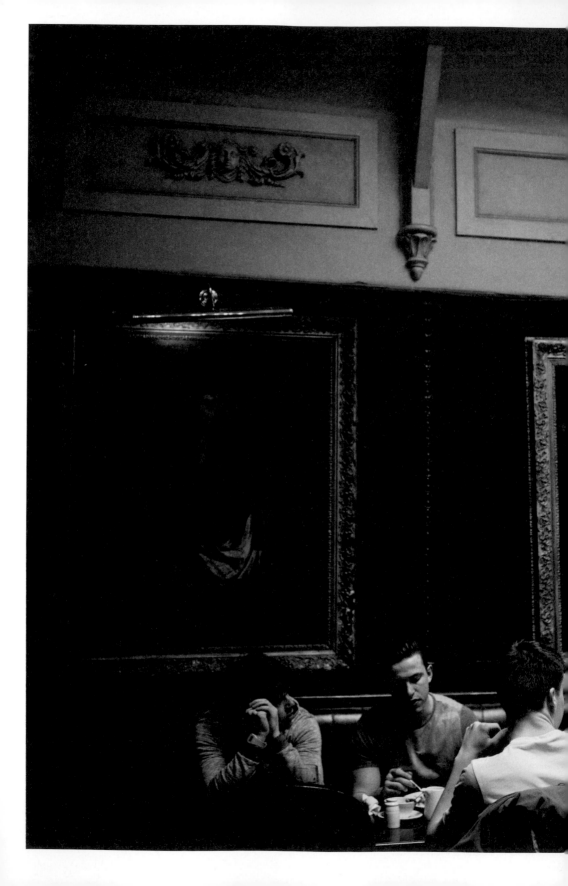

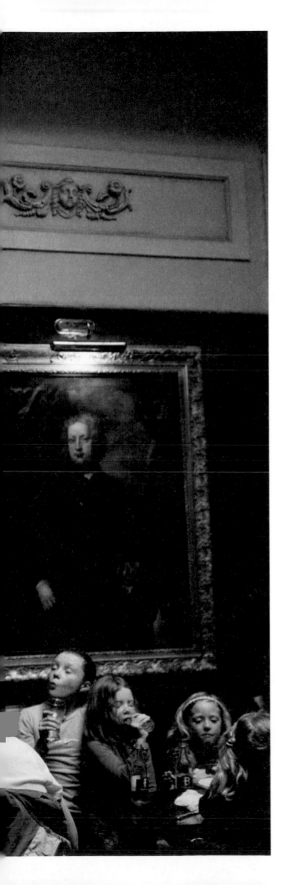

rights and equal opportunities to a
fully fostered by an ab
e people of Ireland and
Irish Republic under the protection
n must, by its valour and discipli
N. In the name of God and of th
her secret revolutionary
the right mom... to reve
right of the people of Ir
the right, nor can it ever be exting
e asserted it in arms. Standing on
rades in arms to the cause of its f
and civil liberty, equal rights and
is of... differences carefully fost
representative of the whole people
e place the cause of the Irish Rep
eme hour the Irish nation must,
of the dead generations from
nisation, the Irish rep

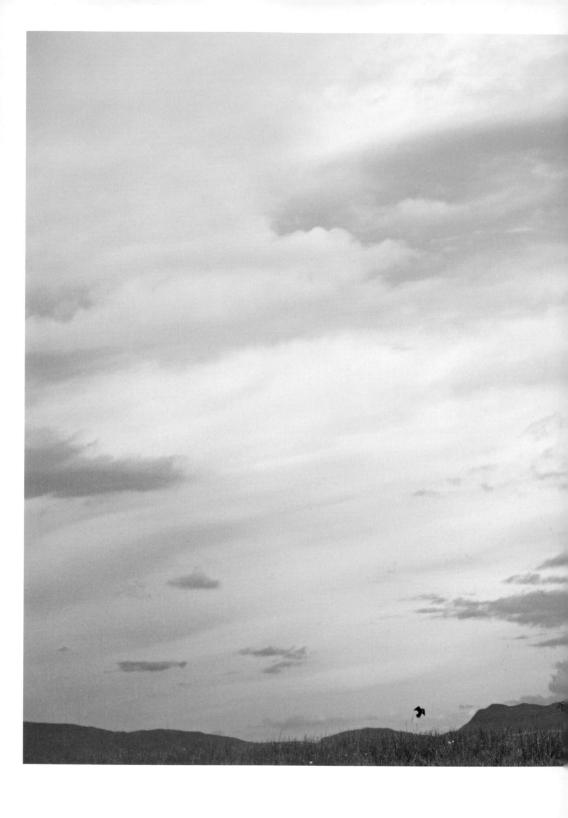

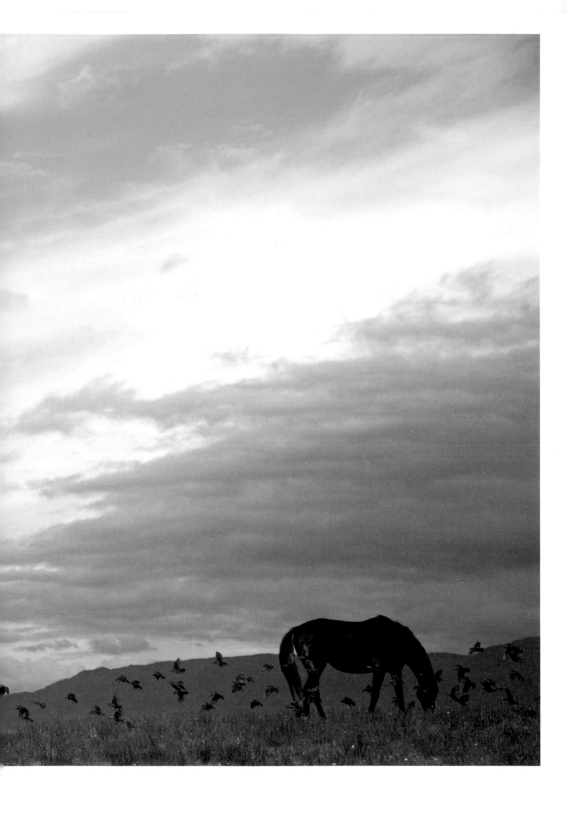

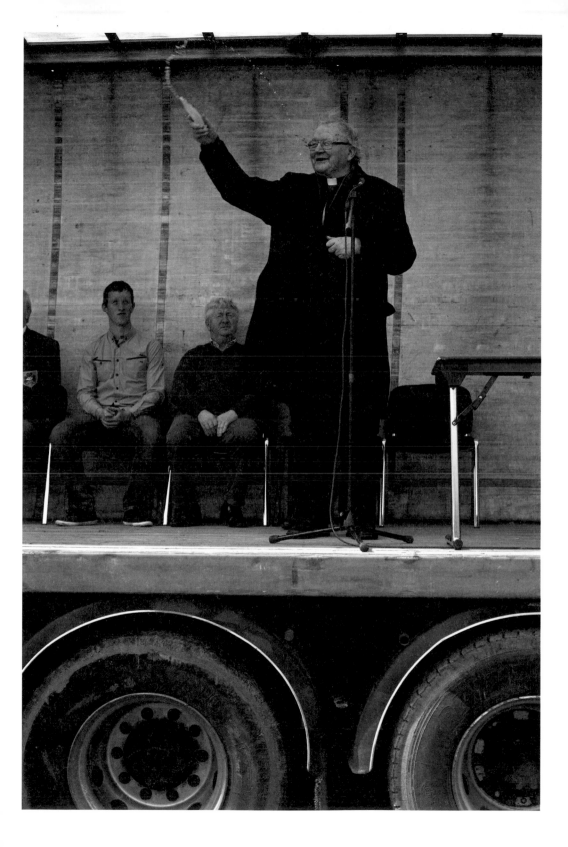

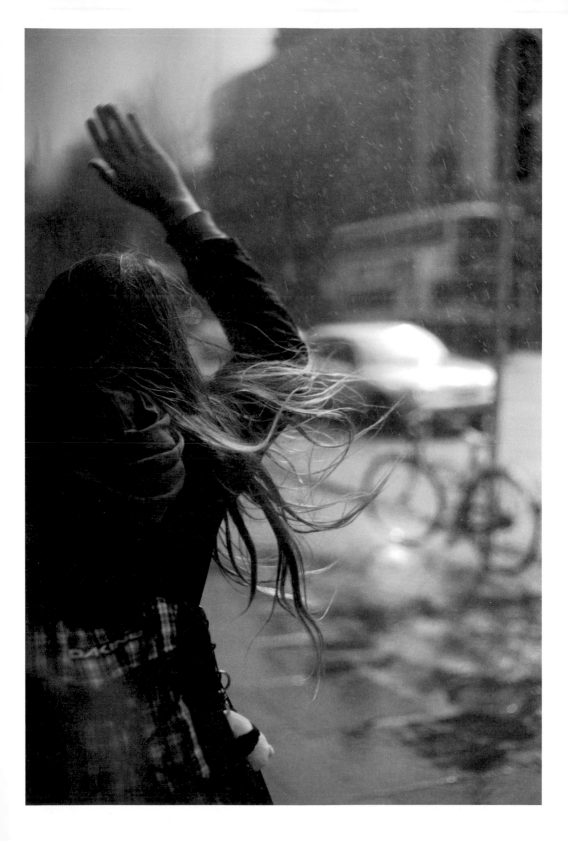

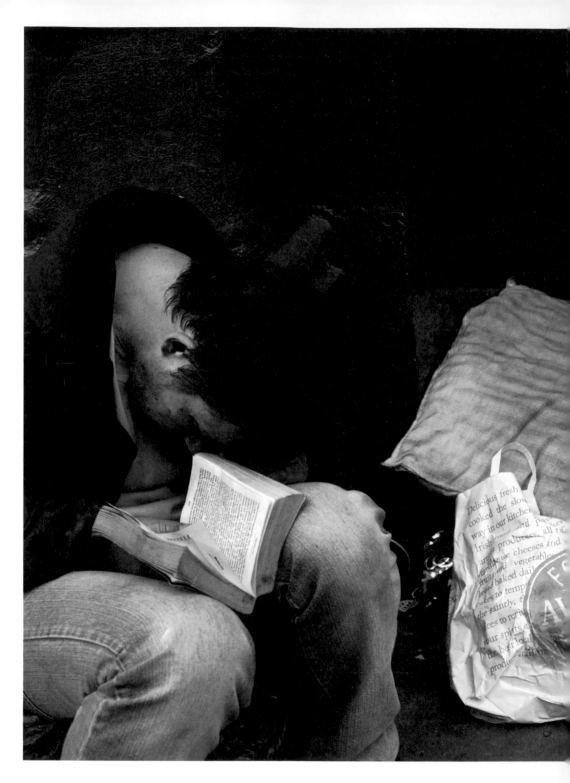

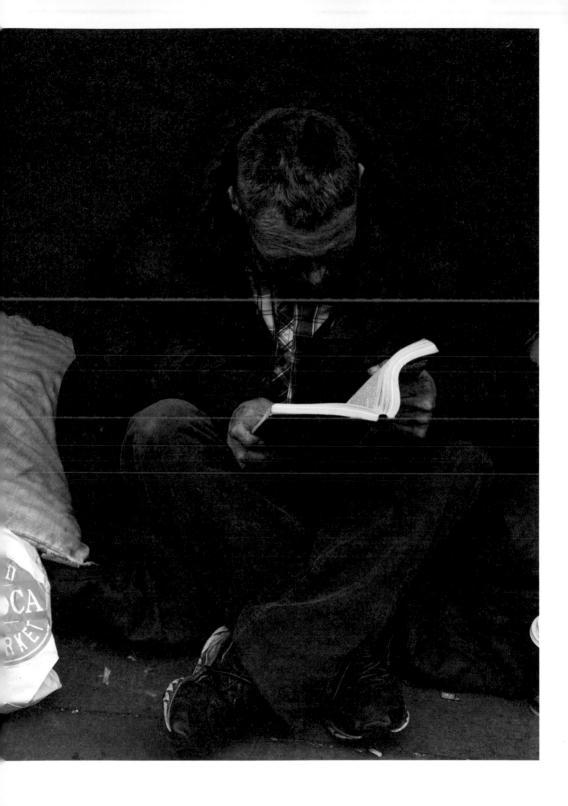

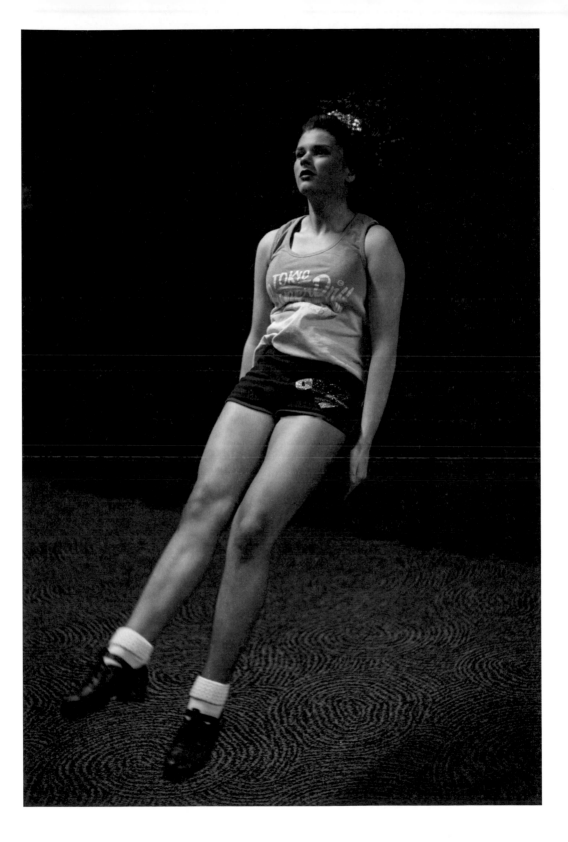

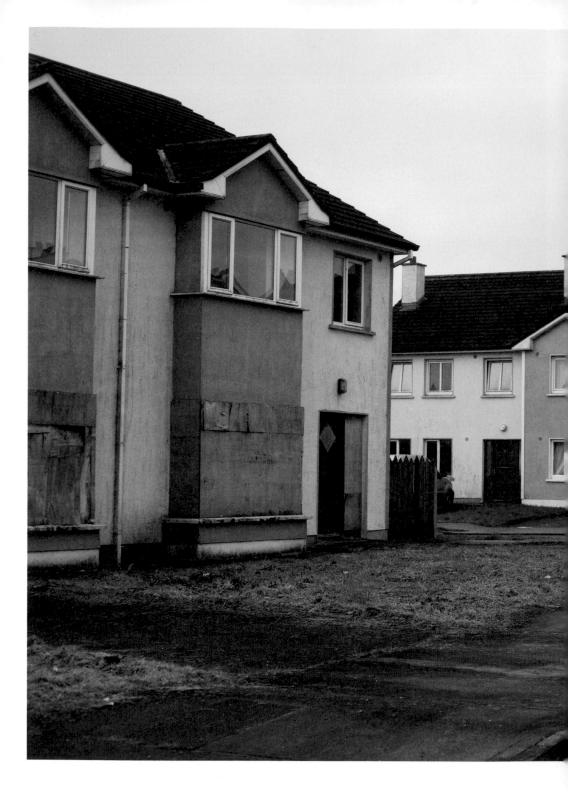

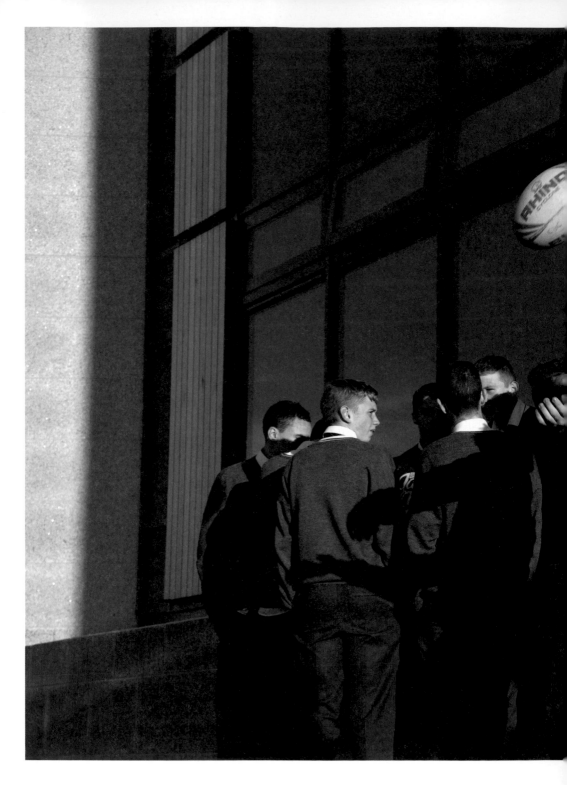

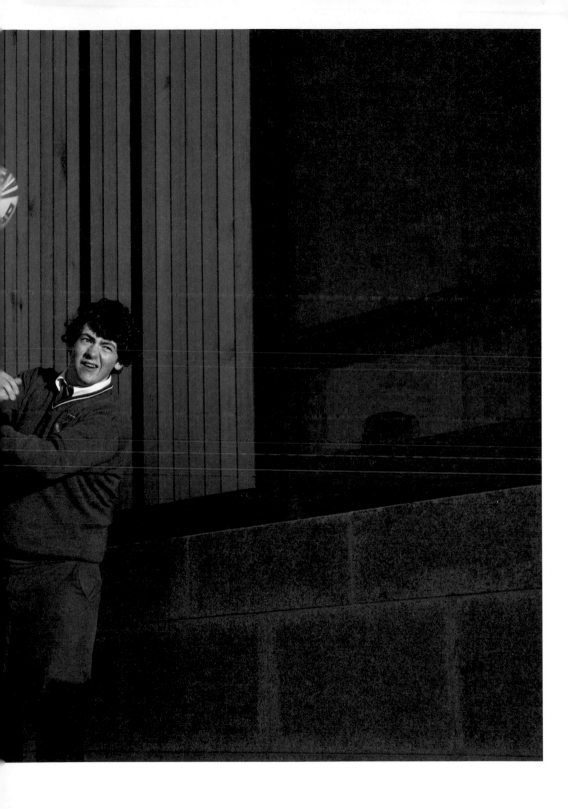

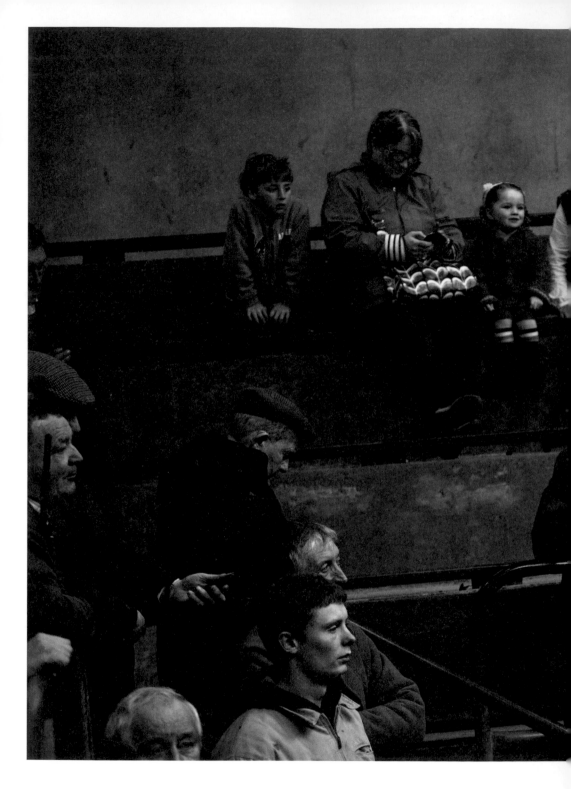

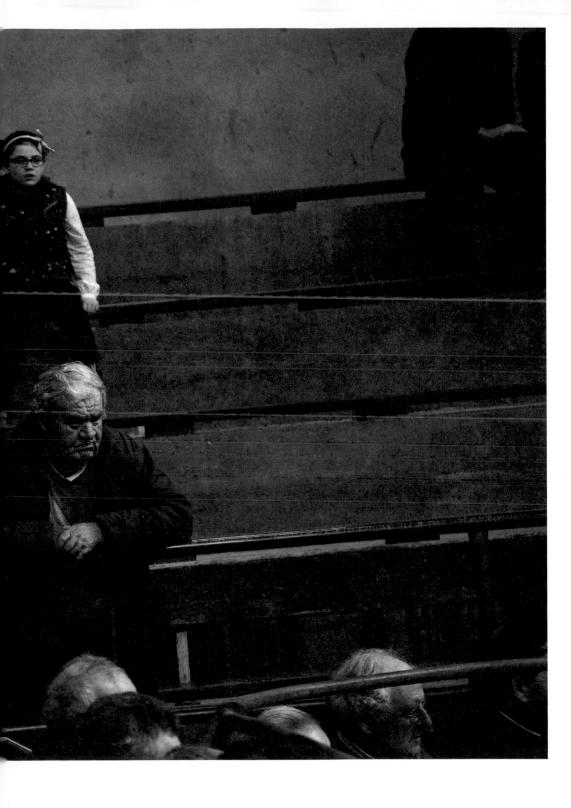

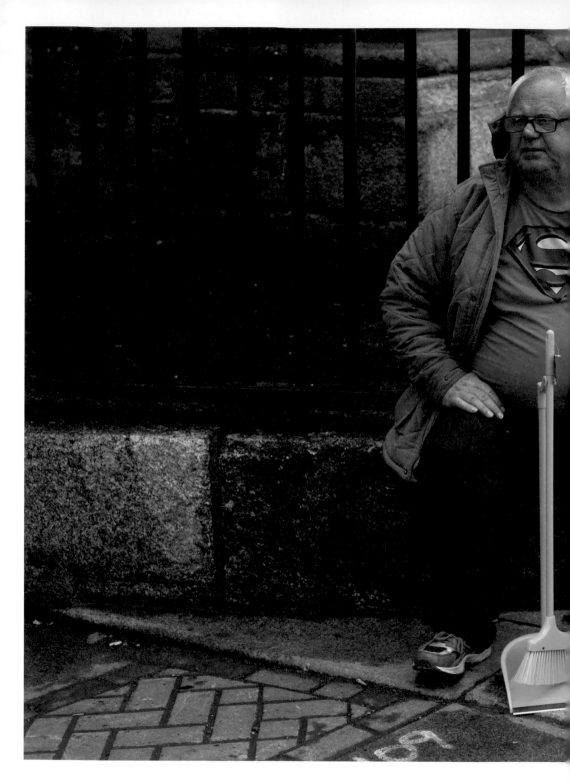

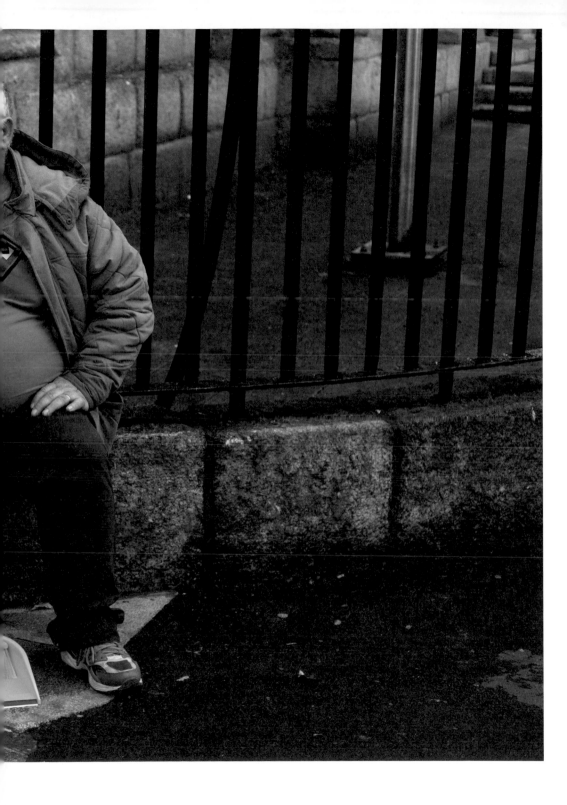

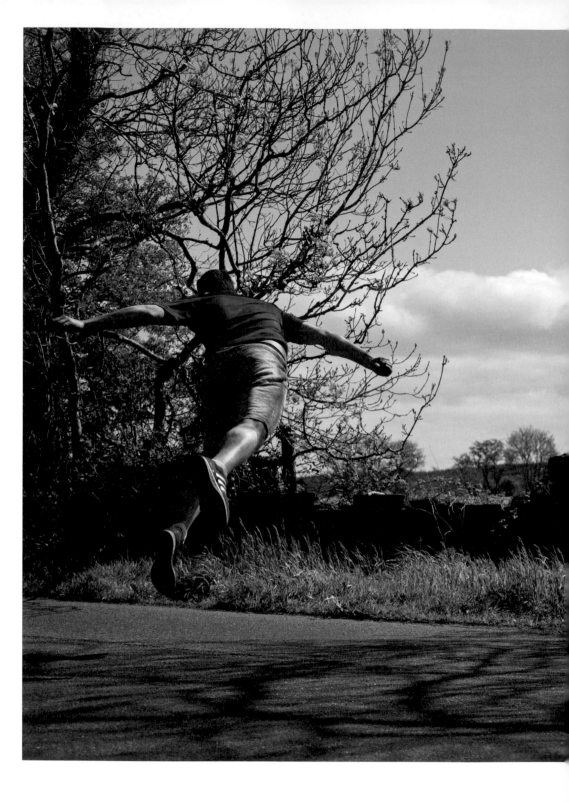

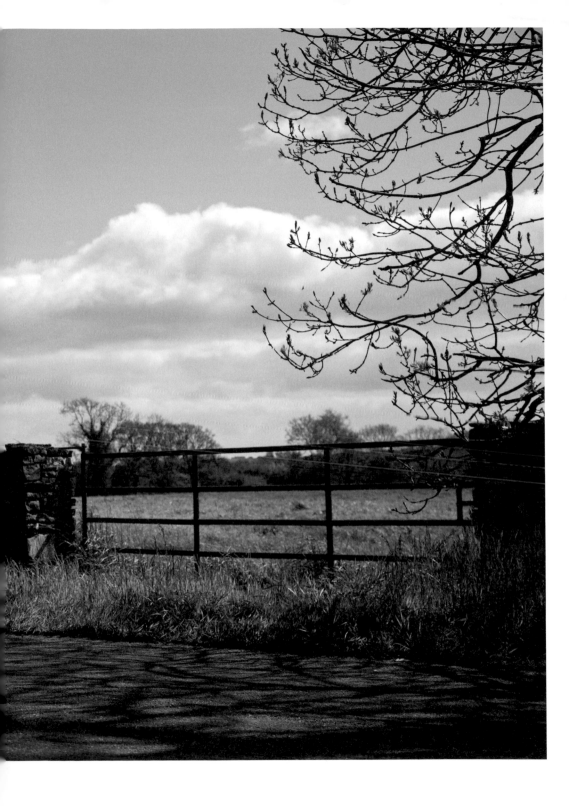

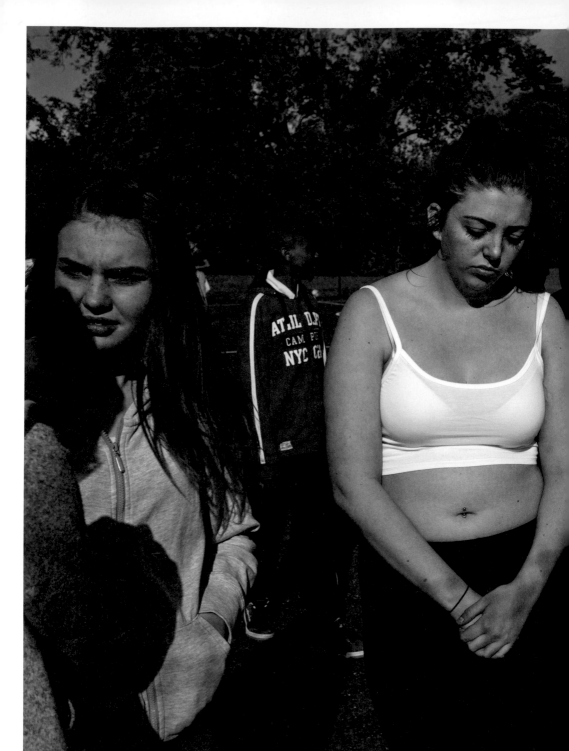

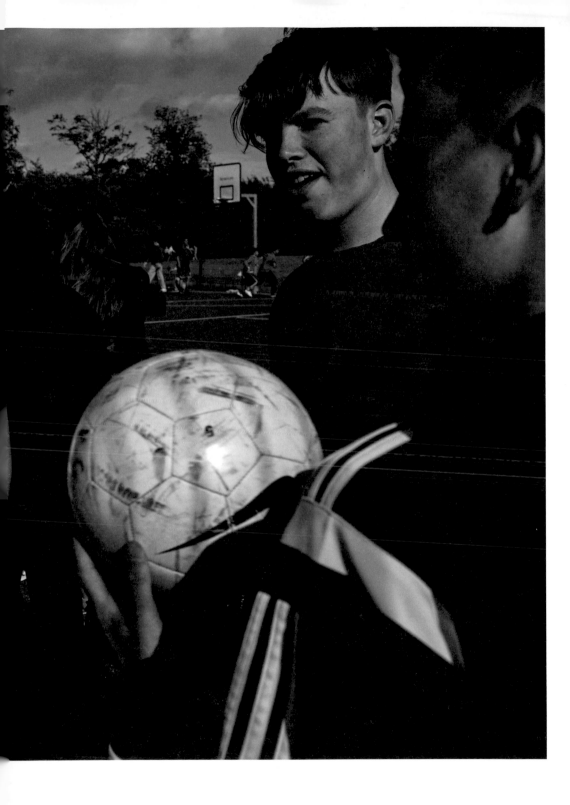

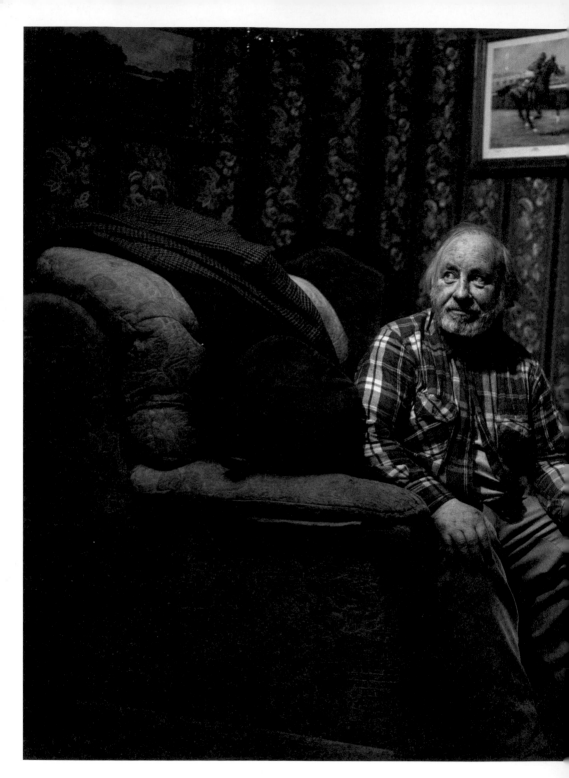

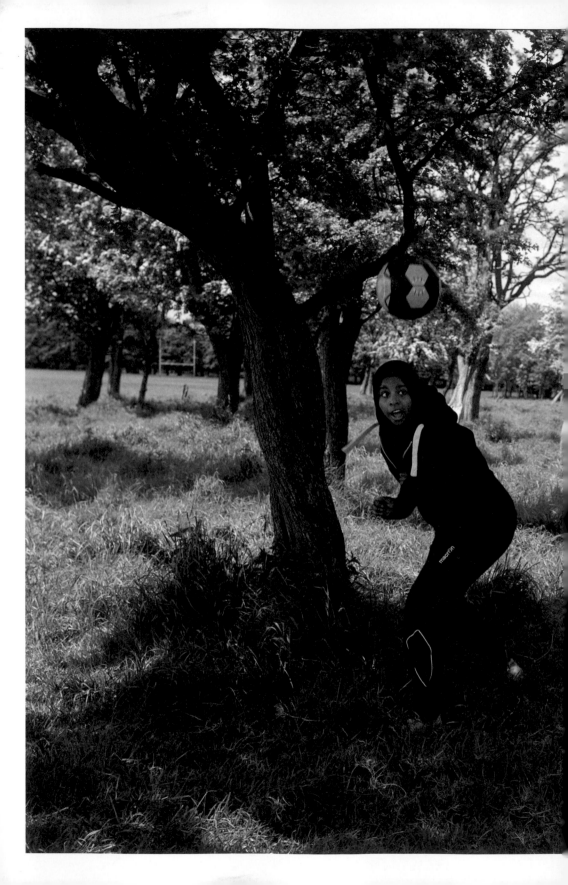

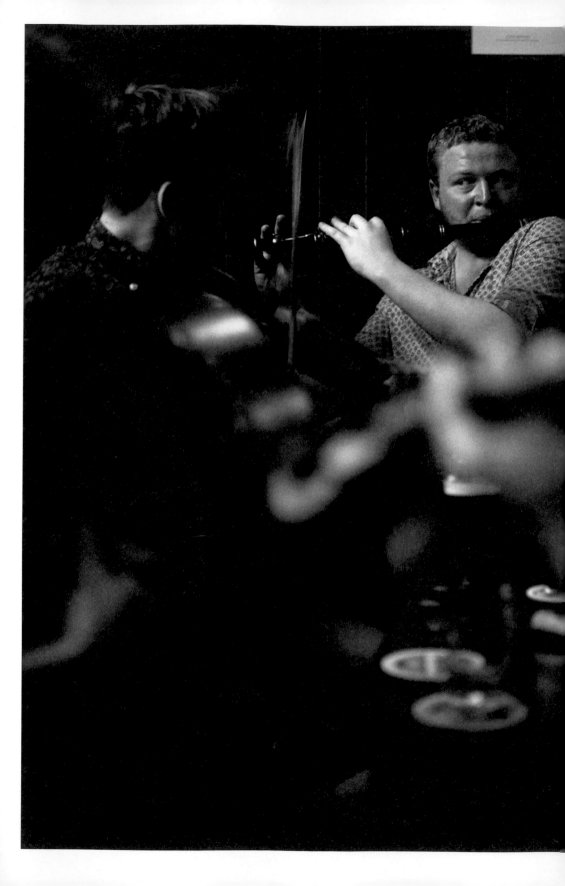

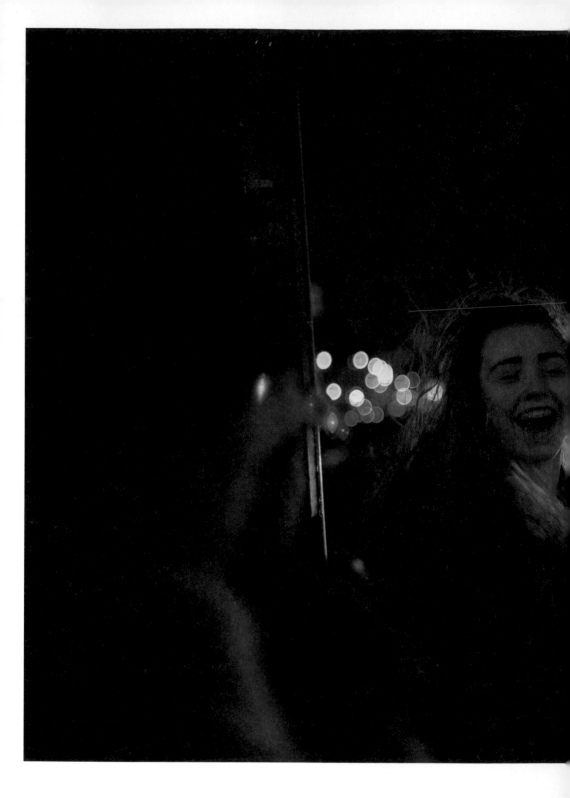

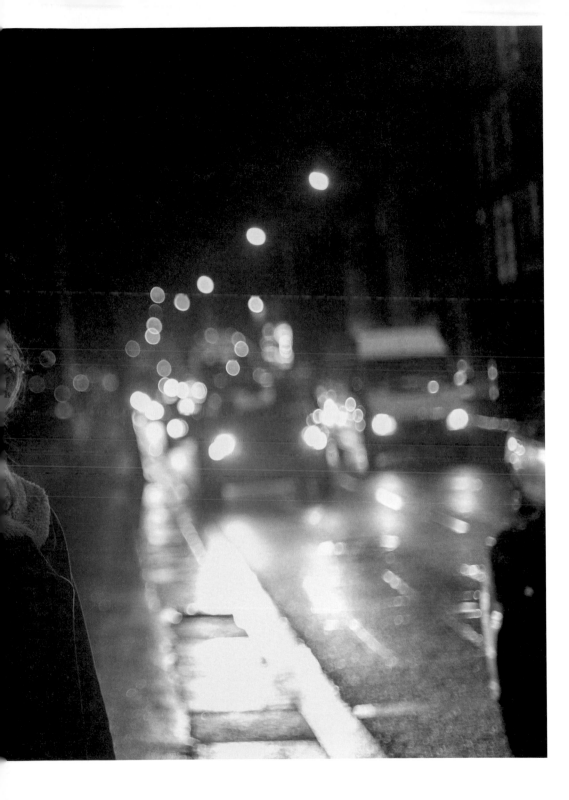

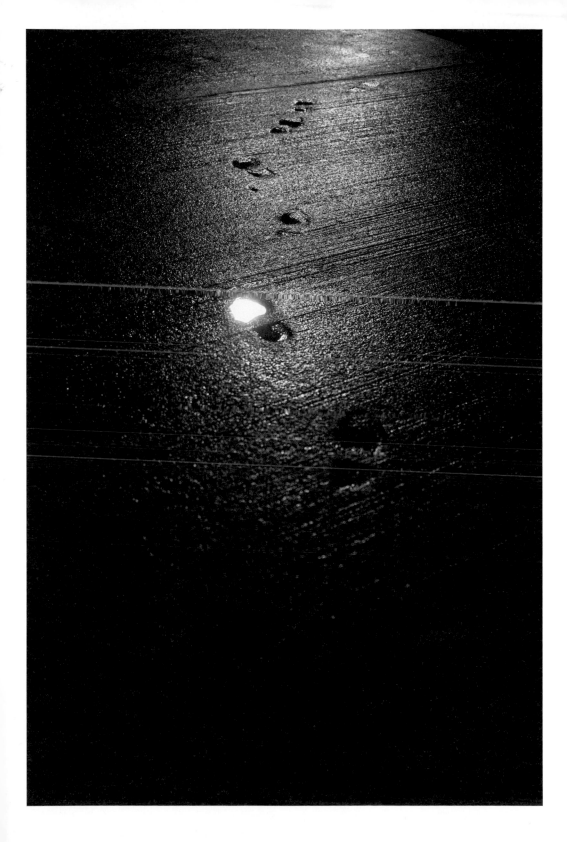

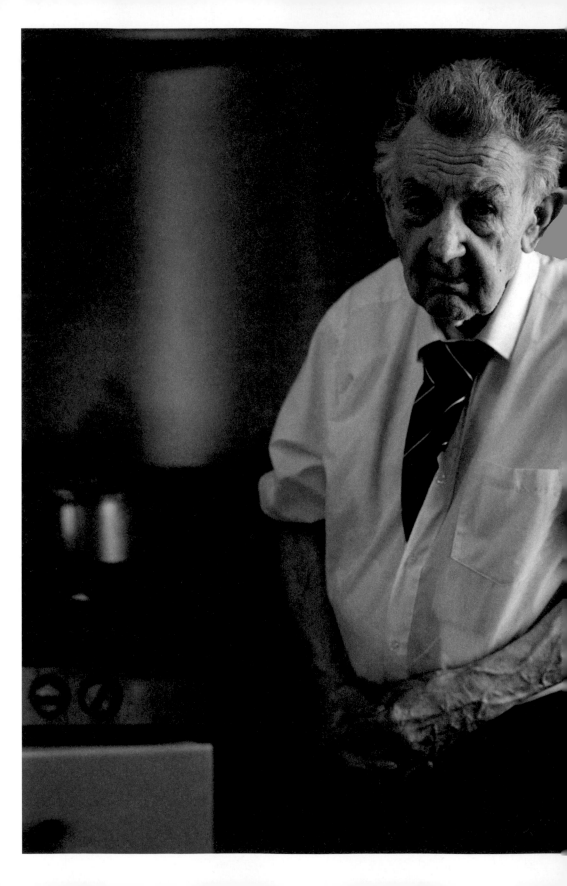

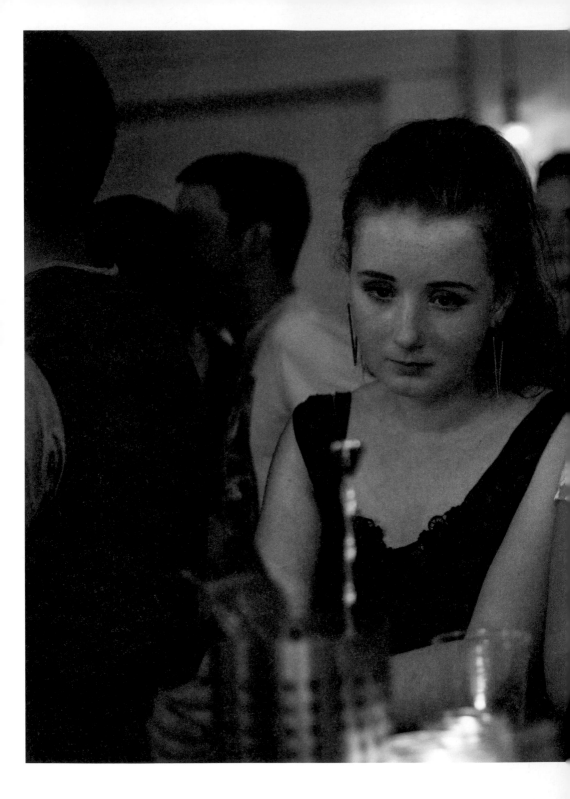

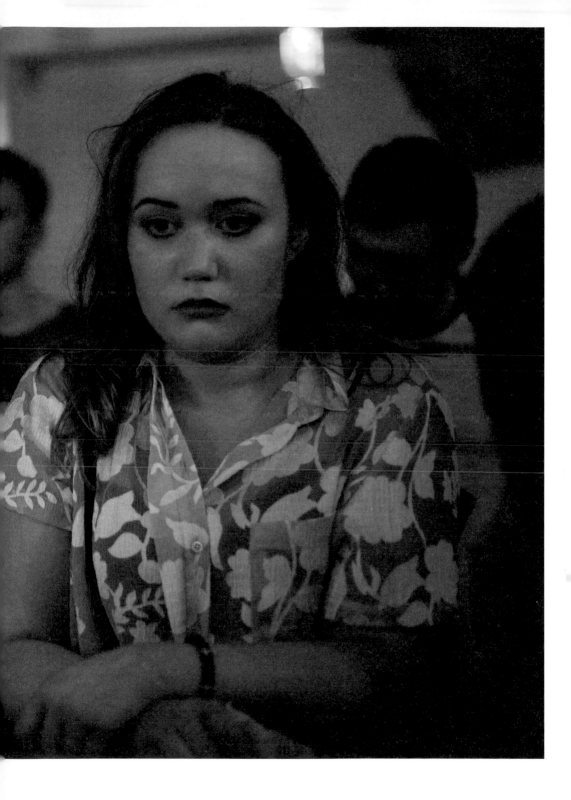

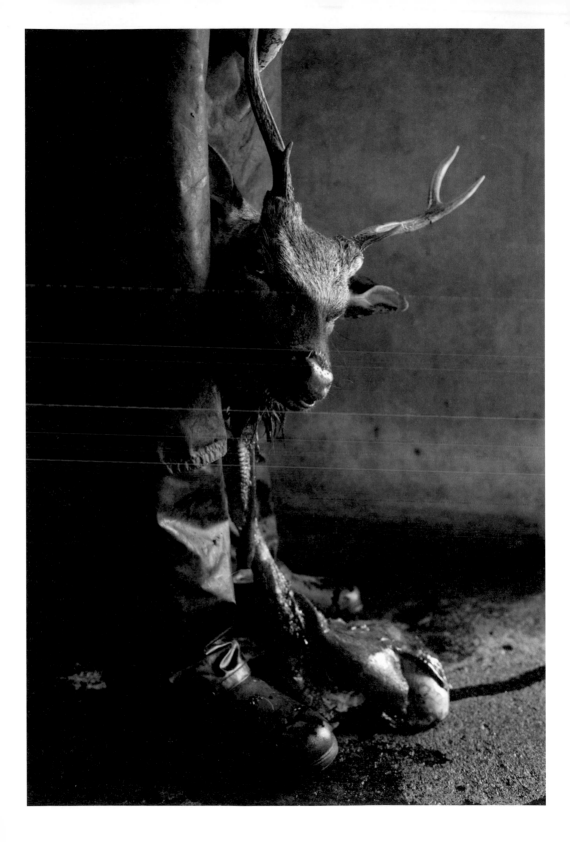

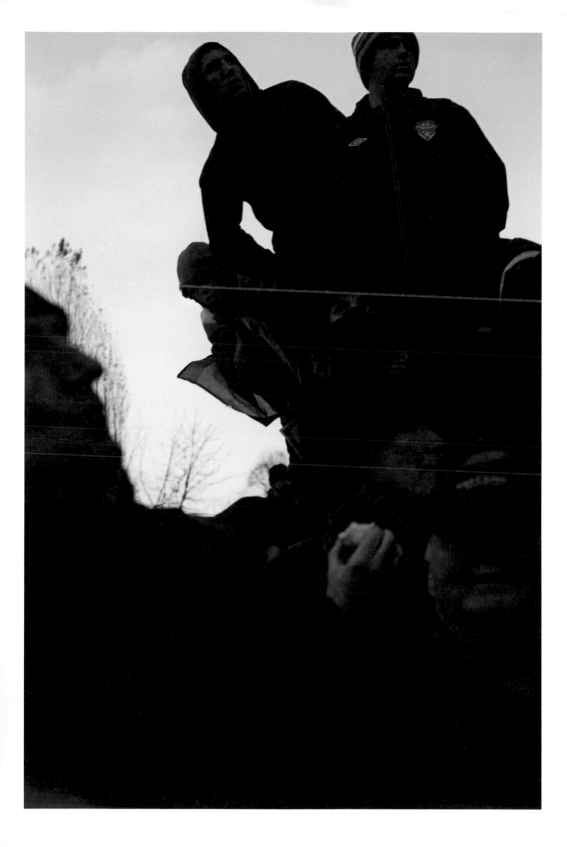

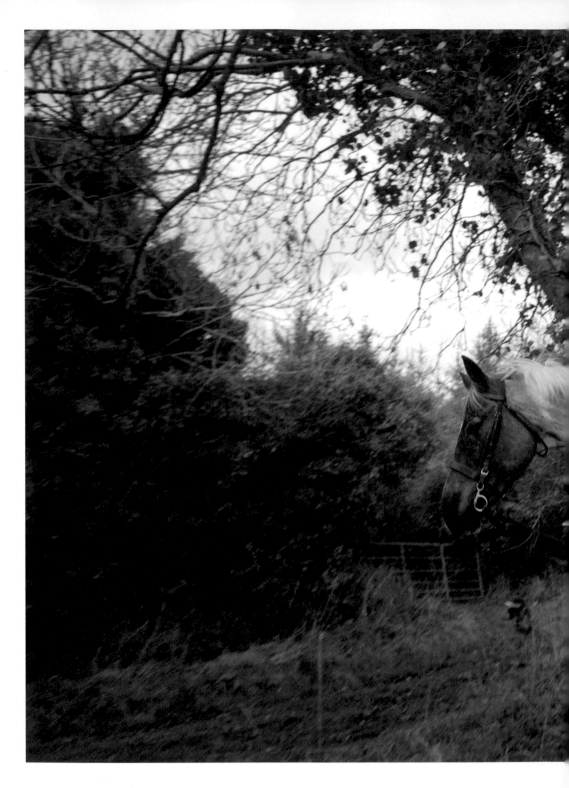

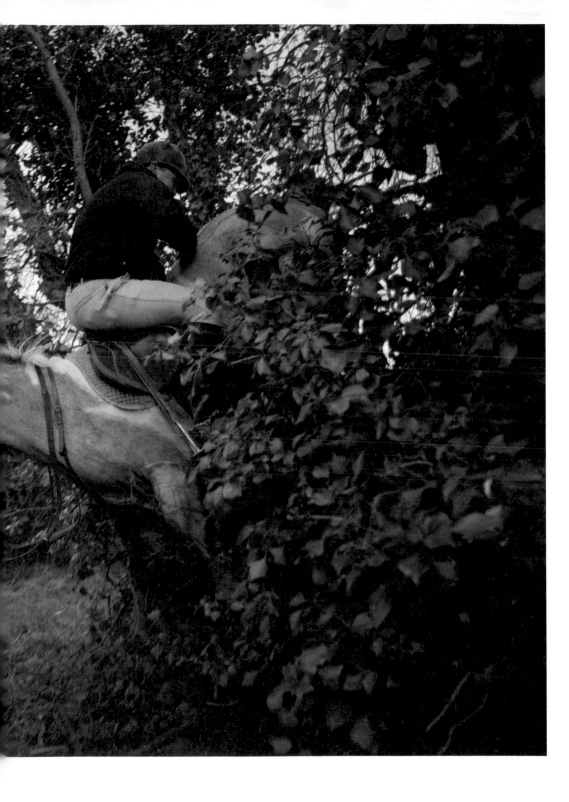

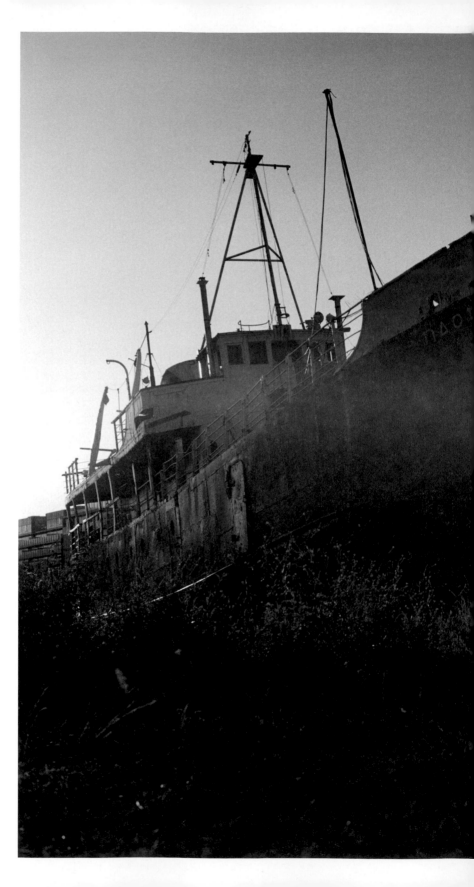

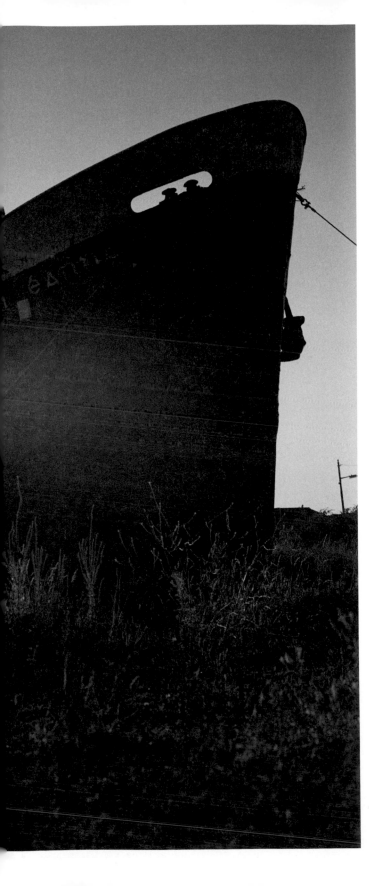

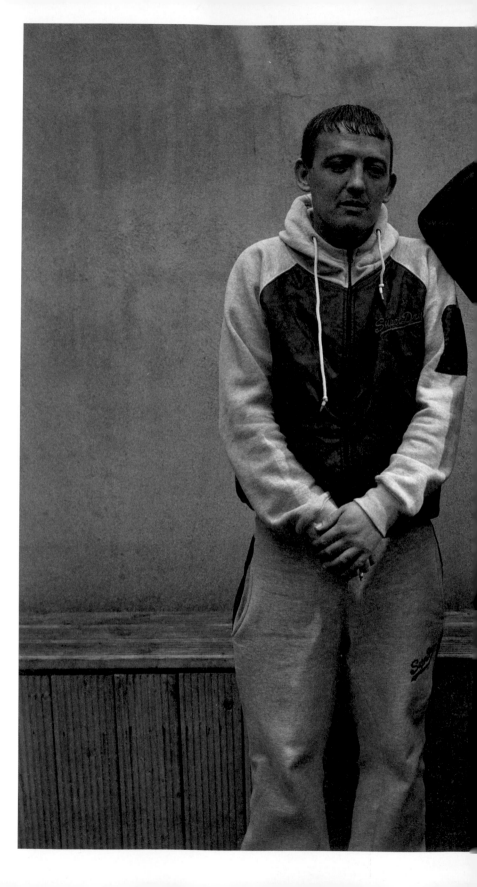

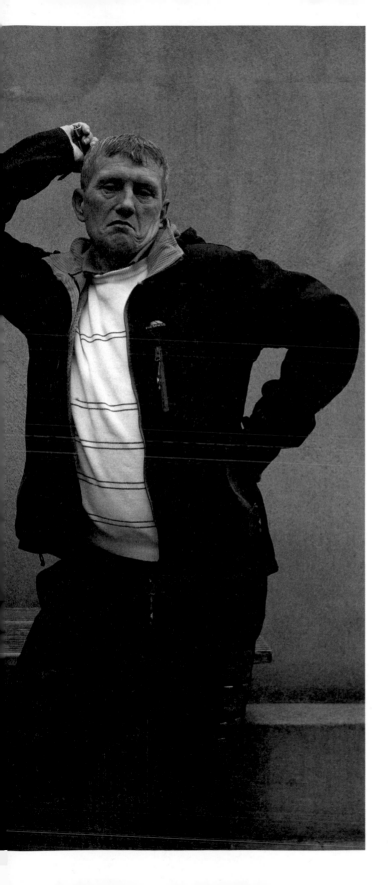

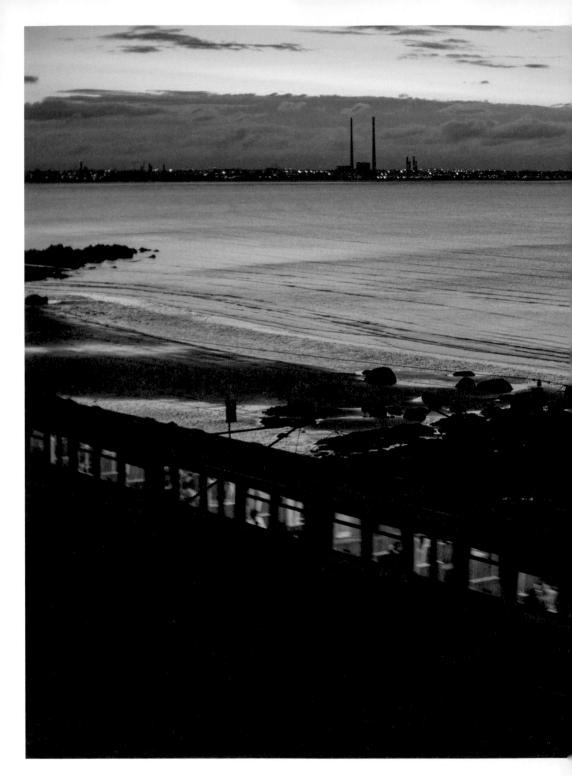

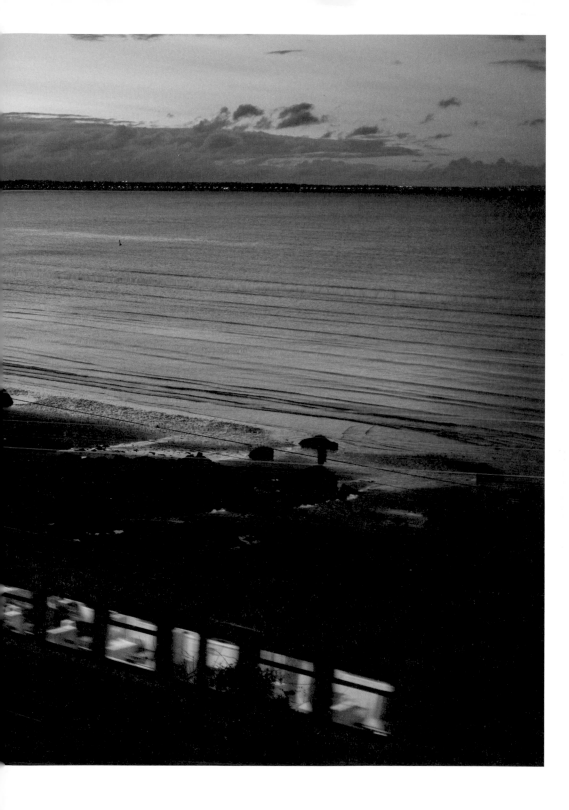

SORROW LIKE TO MY SORROW." *Jer.Lam.C.I.*

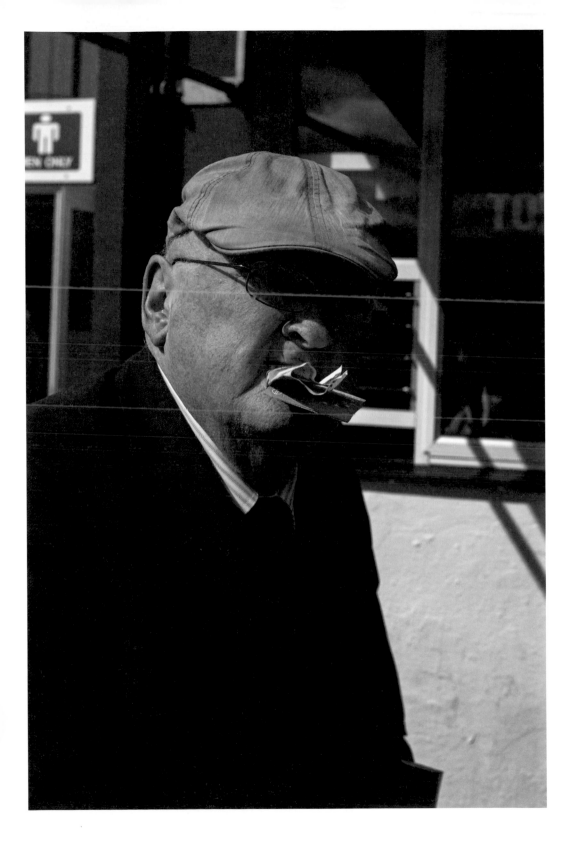

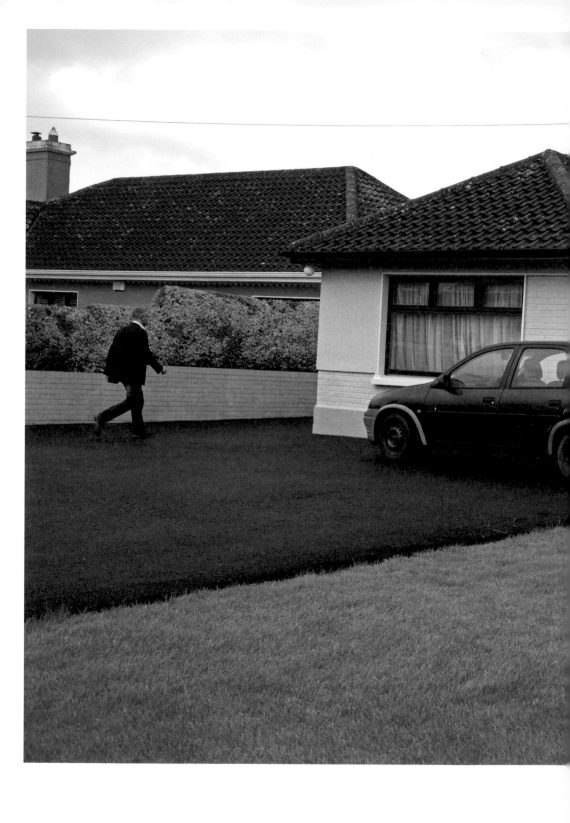

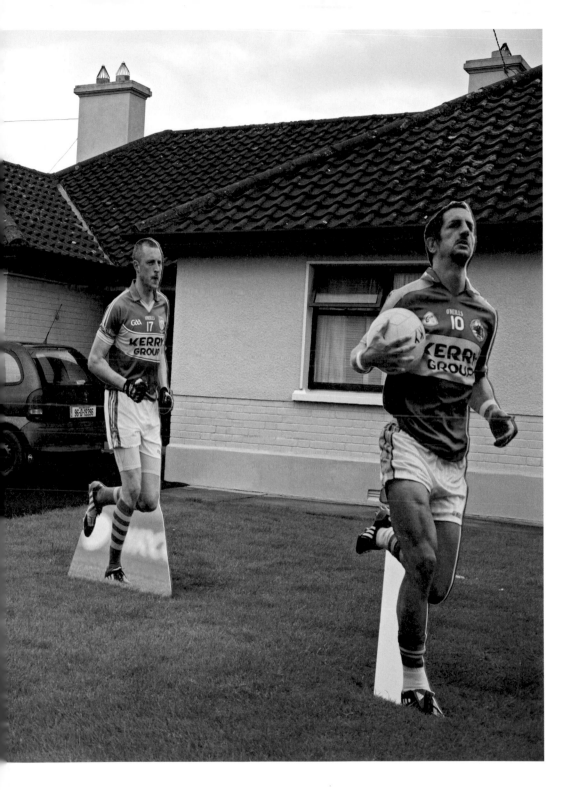

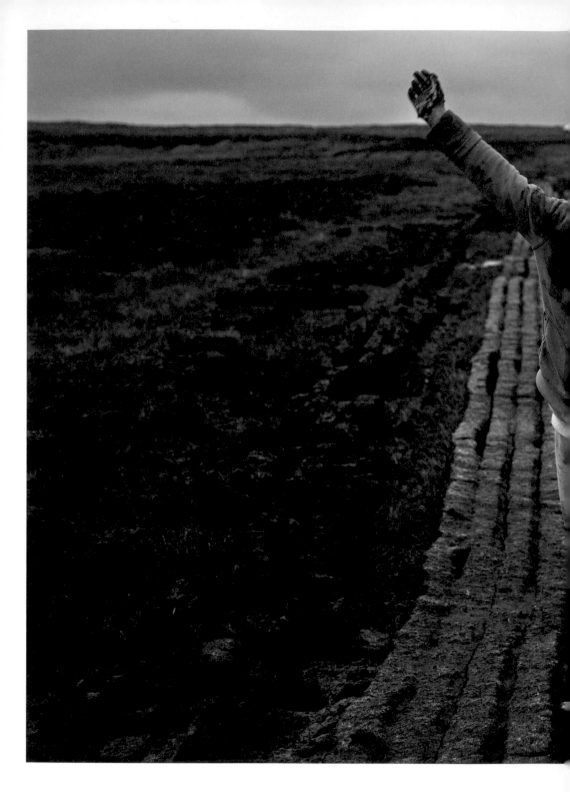

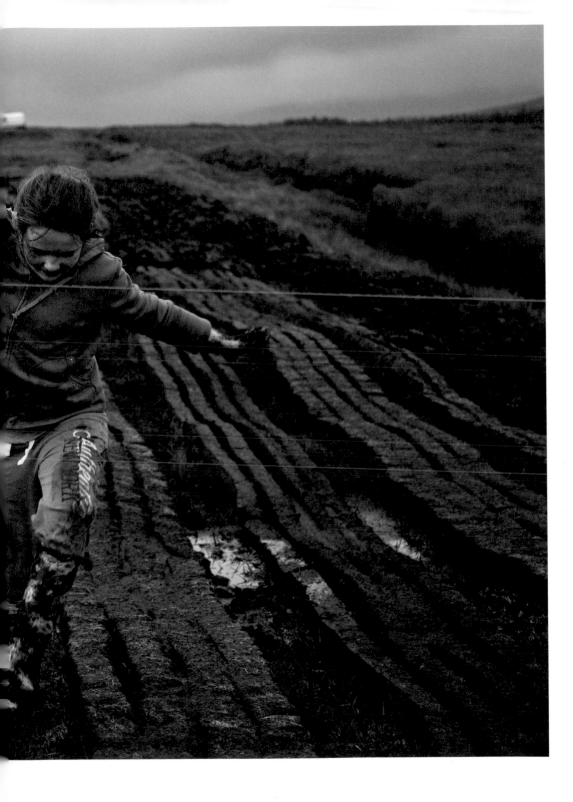

THE REPUBLIC

Unease surrounds the centenary of the 1916 Easter Rising.
There are fears of a party-political hijacking or of giving offence
to the Irish dead of the First World War. Lilies and poppies.
The fluster surrounding the official commemoration in the
Republic reveals a nervousness in the modern state.
Timid bureaucracy, terrible beauty.

On a trip into Syria with FSA rebels in 2012 the idea of
photographing Ireland started to take hold. Trekking silently
for eight hours through regime-held villages under a blanket
of darkness left time for reflection. It took me back to meeting
veterans from Ireland's War of Independence (1919–1921) and
Civil War (1922–1923). I had photographed the surviving handful
in the late 1990s: the youngest was ninety-seven, the oldest
one hundred and five; all are now dead. I photographed John
Snee (IRA East Mayo Brigade Flying Column) at Kilmainham
Gaol in Dublin close to where the leaders of 1916 were executed
(pp. 70–71). War is indeed personal. Since meeting them and
hearing their stories of guerrilla war from a more familiar
context, it made me ponder and equate their experiences with
ones I later encountered in Syria, Libya, Afghanistan and Iraq.
In the thirty years since leaving Ireland I had travelled a lot,
shooting pictures and listening to stories in other people's
countries. What about looking at my own country, which I still
call a home?

A picture I took in 2011 in County Wexford wouldn't
leave me alone. A man rides a horse seated backwards, over a
steep and tricky hedge. An elegant joke if he manages to
stay on, and he does. A glimpse of the comedy we make of life,
death and the rules in Ireland. I had a starting point.

Beginning in the summer of 2014 I spent a little over a
year photographing in Ireland. I went for as long and as often
as I could, travelling around and finding situations as I went.
I occasionally troubled a trusted few for contacts and leads.
Trying to explain to the curious innocent what I wanted was futile
and exhausting, not least because I didn't quite know myself.

I made a lot of discoveries, from makeshift signs on the side of the road: shows of all kinds, point-to-point meetings, Gaelic Athletic Association fundraisers. The event itself was usually irrelevant, the gathering was always interesting. Along the way, in the pub or at the B and B that night, was often where I found the photograph. Talk, intended for my ears or overheard, took me further:

— *A man tells me a police detective told him that the phone PIN code of Dublin criminals is usually date of birth or 1916.*

— *I here of a pub where the alcoholic owner times his weekly falling-off-the-wagon every Sunday, just after midnight. Anyone calling on a Monday to do business with the pub have learned its best to leave their visit until Tuesday.*

— *On the Dart train to Dun Laoghaire a party of six rate the relative qualities of prisons in Ireland. All speak from personal experience in the atonal, adenoidal hum of heroin, methadone and Dublin. The veteran of the group, a man in his forties, is asked about a particular prison another one has been praising. Enjoying the respect of the gathered, he takes his time giving his reply. 'That,' he says, with measured, connoisseurial precision, 'is an excellent prison.'*

— *On my way to a cattle mart in Roscommon I meet local photographer Mick McCormack in Ballaghaderreen. He tells me to look out for Maura the manager there. 'You can mention my name,' he says, 'but it may not help. The last time I was there I was doing a story for a Dublin tabloid on Benjy the gay bull.'*

— *Pulling in to ask directions for a housing estate on the outskirts of a town in the west, the man helping me seems reluctant to let me go. He wants to tell me something but is having trouble saying it. Finally, as I begin to pull out he blurts: 'Will you be carrying a sawn-off to take with you?'*

— *A man in his seventies accompanying his wife on her daily swim at Sandycove, south of Dublin, remarks on the Rolleiflex film camera I occasionally use. The camera was like taking an exotic dog out for a walk: it attracted interaction with strangers. He told me*

he used to have a Rollei and we talk about photography and what it means to us. As I say goodbye I offer my hand and my name. A current of panic ripples across his face. He tells me he has a strange name. There is silence between us and I wonder what will come next. 'They called me Adolf,' he says with a crooked smile.

I suppose I was looking for what often goes unnoticed and unrecorded, what moved and surprised me. It may not seem a fitting or worthwhile task in the centennial year of 1916, but the Rising has been called a poet's revolution, and beyond all the revision, myths, politics and spin there should be some room left for dreams and wonder. After all, looking up at the stars on a clear night over County Roscommon can get a person thinking.

It is inevitably going to be personal. Everywhere along the way I saw and heard things buried under shallow layers of memory. On my first trip west last year I recalled names of places glimpsed from the back seat of the car on family trips to my father's home county of Mayo. This time it's me driving. Mullingar, Longford, Tulsk. And Ballaghaderreen, whose dog-eared turn at the far-end of town makes me remember it.

I began writing this on the car ferry from Holyhead on my last trip to Ireland for the book. I am taking the same route that my family – having lived in England for some years – took as they returned seasonally to Ireland. I am the youngest of six, and aged six months my first trip to Ireland is our final journey home. Of legend, Irish people crossing the Irish Sea faced officious, rude customs officials at Holyhead that we would probably now call racist. Today Islamic State is the current threat and with commercial competition from Ryanair the passage has less of the Gulag to it.

The family's move home in 1960 was a new beginning in what must have felt like a young country. England next door heckled from the pirated television channels we picked up living on Ireland's Eastern seaboard. It's now called soft power, but in some ways the BBC helped in defining Ireland by showing and telling us what we weren't. One evening I was watching the clock on the television screen, counting down

the minutes until the programmes began on RTÉ, the Irish broadcaster. But the clock must have been slow. A furtive finger appeared from a very hairy hand and propelled the minute hand to the correct time. The presenter magically appeared. In this breaking of the fourth wall the clock, which I imagined as monumental, appeared tiny beside King Kong's digit. Watching television has never been the same since.

Our return spawned in my mother, herself second generation Irish, a profound loyalty to Ireland, the excesses of the clergy notwithstanding. A family favourite was spotting nuns and priests driving a Mercedes. Particular opprobrium (and delight) was reserved for those ecclesiastical speedsters who also sported shades. They wouldn't dare do it now.

Thinking back to the fiftieth anniversary of the Rising in 1966 – I was six – my memory of it is still sharp. I experienced fear and excitement watching *Insurrection*, an Irish television drama based on the events of the Rising. It shook my sense of security and order. I was familiar enough with guns and cowboys and Nazis, but not on O'Connell Street. It was a familiar and comfortable place with Clerys department store, a few ice-cream/amusement cafes, a man who took your photograph as you walked past him, and a huge post office. The blowing-up of Nelson's Pillar on the street that year was the IRA's fiftieth birthday gift to us and seemed to be widely considered a touch comical. I had never been to its top to see the view over Dublin. History taught at my school meant Ireland Good, England Bad. I was born in England, which caused a stir at school whenever I was asked where I was born. From childhood memory, the North wasn't discussed much anywhere until the civil-rights stirrings in 1969, which in the south provoked some action but mainly gestures of impotent nationalism. Institutional signals on the subject were subtle. The back-cover of our school exercise books had a map of Ireland depicting all thirty-two counties, not just the twenty-six that makes up the Republic. No indication of partition. From 1937 the Irish constitution included a claim on the six counties of Northern Ireland, which was dropped by referendum in 1998 as part of the Good Friday Agreement.

Growing up in Dublin in the 1970s, the country that Patrick Pearse and the other revolutionaries begat was a place of frustration. I wasn't particularly angry or unhappy, but Ireland felt like a sideshow, with priests acting as shabby park-wardens, or more seriously as the police. We now know so much more about what went on. With every book, film or piece of music I digested the world beckoned and the road led elsewhere. The weather forecast lilted the deadly futility of it all: sunny spells and scattered showers. I didn't think it was the place to be young. I couldn't wait to leave.

Horses were bound to figure in the story. My first break in photography came after I saw kids drift past me bareback on horses in Finglas on Dublin's north side. December 1988, I was waiting in the car while my father made a house-call as a GP. I was in Dublin for Christmas having returned to live in London after a few years in California, where I started taking pictures. In London I had been struggling in the film business as a camera assistant, beginning to think photography could offer a better way.

What struck me was the acceptance of horses living on urban housing estates with kids managing and caring for them. From being away I recognized this would not be normal elsewhere. The kids told me they kept horses in their tiny back gardens, and a horse-market took place every month at Smithfield in the centre of Dublin. In fact kids had re-invigorated Smithfield Market, showing an innate way with the animals, confidently mixing with the Travellers and horse-dealers up from the country. The pictures I shot with a ripe New Year's Day hangover were published over the back-page of the *Independent* in London a few weeks later. I was a photographer.

Now, over thirty years since leaving, an exile, escapee and outsider, I could try again.

Seamus Murphy

CAPTIONS

Front cover: Co. Roscommon
Back cover: Killarney, Co. Kerry
Endpapers: Carrowbey, Co. Roscommon

ACKNOWLEDGEMENTS

My parents **Binkie** and **Jimmy**, for taking the journey back and making Ireland
our home.
My wife **Smita**, who wanted this book as much as I did and made it happen.
She's a damned fine editor too.
The Tearaways of Tradescant Road – **Avinash**, **Nihal** and **Ashwin** – for all they have
given us.

My family in Ireland for great support and encouragement: **Nuala**, **Carmel**,
Aran and Willie, **Garret** and **Susan**, **Clare and Hugh**, **Naoimh and Sean**. **Aoife**, **Max**,
Lucia, **Caspar** and **Reggie**. **Rory**, **Seamus** and **Luan**. **Andrew** and **Kieran**.

Jocelyn Bain Hogg for his help in editing the pictures and always seeing me right.
Nicholas Barker for his help in sequencing the pictures.
Designer **Lizzie Ballantyne** who worked hard at making it look simple.
Helen Conford at Penguin for all her encouragement – and calm.
Caroline Cortizo for looking after the pictures.

Friends, saints and colleagues: All who work at and visit the Peter McVerry Trust,
Emma Atkinson, Dr. Gerry Berry (CBC Monkstown), Mustafa and Kay Bhujwalla,
Sean Burke, Mícheál Coughlan (Ballyoran), Joe Creedon (Inchigeelagh),
Gerry and Margaret Cronin and Ronny Galvin, Jim Cusack (*Sunday Independent*),
Kevin Dolan, Mark Dowling (Colaiste Pobail Setanta in Ongar), Sé Merry and
Anne Merry Doyle, Ozzie and Frances D' Souza, Helene Duffy, Eithne and Maireid
Garvey, Shannon Ghannam, Mia Manan Hameed (Irish Sufi Foundation),
Dublin City Mosque (Anwar-e -Madina), Robert Hayes, Eamonn Henry (Tullamore),
Pat Ingoldsby, Pat Kearns (North Galways), Micheal Keegan (Waterfall Farm),
John Kelly (Ennis),Jarlath Keogh and Dan Quirk, Rob Kirwan, Liam Lavelle (Agtel),
Paul M (Ballymun), Cauvery and Prakash, Madhavan, Niall Martin, Peter Meaney,
John Minihan, Pat McCarthy (Irish Road Bowling Association), Chris, Matthew and
baby Jamie McCormack, Laura and Nikita Kavanagh (Swords), Mick McCormack
(Ballaghaderreen), Ken McCue (SARI, Sports Against Racism Ireland),
Henry McDonald (the *Guardian*), Fr. Peter McVerry, Eoin O Liethein, Timmy O Reilly
(Hebron Road), Tony O Shea, Richard Oyewole (African-Irish Sports Association),
Paul Perth and Amel Yacef (Bluebell Youth Project), Jimmy Prendergast (Finglas),
Shane (PantiBar), Nell Regan, John Spelman and Bernie Coleman (Ballaghaderreen),
John Stafford (Killinick Harriers), Emer Woodfull.

Thanks to all those who helped me along the way with this book. It might have been
just a few helpful words but it made the difference and kept me going.

ALLEN LANE

UK | USA | Canada | Ireland | Australia
India | New Zealand | South Africa

Allen Lane is part of the Penguin Random House group
of companies whose addresses can be found at global.
penguinrandomhouse.com.

First published 2016
001

Text and images copyright © Seamus Murphy, 2016
Lines from *Juno and the Paycock* by Seán O'Casey reproduced by
courtesy of Faber and Faber.

The moral right of the author has been asserted

Design by Lizzie B Design
Printed in Italy by Graphicom srl
Repro by Altaimage Ltd

A CIP catalogue record for this book is available from the
British Library

ISBN: 978-0-241-19709-7

www.greenpenguin.co.uk

Boyle: An', as it blowed an' blowed,
I ofen looked up at the sky an' assed meself the question
— what is the stars, what is the stars?
Joxer: Ah, that's the question, that's the question — what is the stars?

Juno and the Paycock, Seán O'Casey (1924)